IMAGES
of America

LAKE PLACID

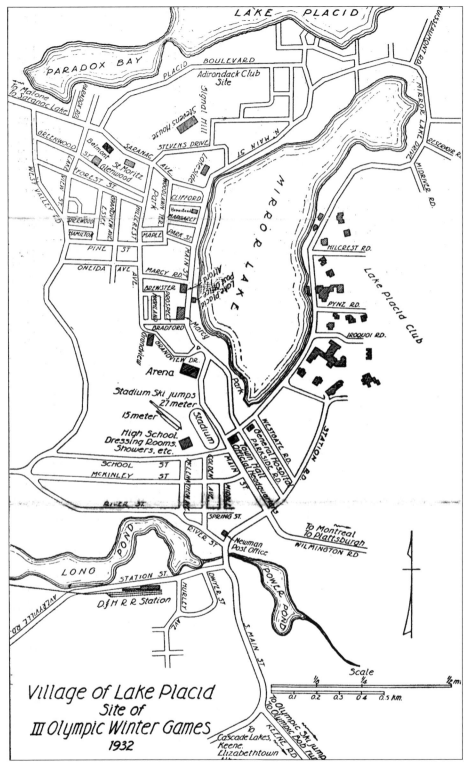

This map shows the village of Lake Placid as it appeared in 1934.

IMAGES
of America

LAKE PLACID

Dean S. Stansfield

ARCADIA

First printed in 2002.

Published by Arcadia Publishing,
an imprint of Tempus Publishing, Inc.
2A Cumberland Street
Charleston, SC 29401

Printed in Great Britain.

Library of Congress Catalog Card Number:

For all general information contact Arcadia Publishing at:
Telephone 843-853-2070
Fax 843-853-0044
E-Mail sales@arcadiapublishing.com

For customer service and orders:
Toll-Free 1-888-313-2665

Visit us on the internet at http://www.arcadiapublishing.com

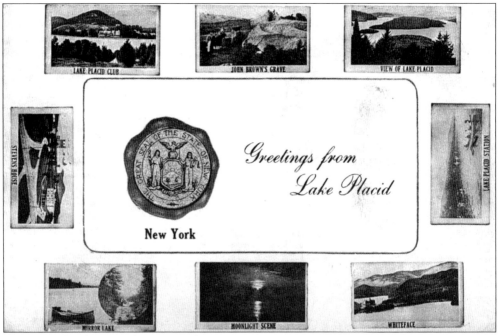

The Lake Placid area is shown in eight views c. 1905.

CONTENTS

ACKNOWLEDGMENTS

First and foremost, I want to thank Mary MacKenzie, recently retired historian of Lake Placid and the town of North Elba. She is an invaluable historical resource and has answered many of my questions over the last few years. Her articles published in the mid-1990s in the *Lake Placid News* about the larger Lake Placid hotels were also invaluable.

I also thank David H. Ackerman for his help with information on Placid Lake camps. His book *Placid Lake: A Centennial History* was an important reference resource. It was his original idea to use the Placid Lake designation to avoid confusion.

Laura Viscome's column "Bits of Lake Placid 20th Century History" in the *Lake Placid News* has also been very useful.

Thanks are also due to Julie Turner of With Pipe & Book in Lake Placid for planting an idea in my head about writing a book on Lake Placid postcards and photographs.

A thank-you is ultimately due to all of the local photographers who worked in the village and town in the first 50 years of the 20th century. Without their photographic documentation of the natural scenery, daily activities, and man-made environment, there would be no book as presented here. Their names are W.F. Cheesman, Grover Cleveland, Roger Moore, Chester D. Moses, Eugene H. Pierson, G.T. Rabineau, and Irving L. Stedman.

INTRODUCTION

The first tourists began coming to Lake Placid in the early 1850s. At that time, the area around Mirror Lake consisted of only two farms, belonging to the Nash and Brewster families. During these early years, the Nashes began accommodating a few paying overnight guests at a time. They soon added extra rooms to their farmhouse. From these humble beginnings, the world-famous Adirondack Mountain resort village of Lake Placid slowly grew. By the beginning of the 20th century, there were four large hotels and many smaller ones where guests could spend their summers in the beautiful mountain lake environment.

In 1898, the U.S. Postal Service approved a new type of card that could be mailed for 1¢. These were called private mailing cards. The sender had to put the recipient's address on one side, and there was room on the other side for a picture and a message. Commercial printers started distributing these cards in resort areas and small towns all over the country. By 1908, these cards soon evolved into the present style of postcard and were sent by tourists to their relatives and friends all over the world. In the early 20th century, it was a very popular hobby to send and collect picture postcards.

At the same time, photographers were taking pictures of the beautiful Adirondack countryside and village scenes. Most of these photographers began printing some of their photographs on special postcard-sized photographic paper with a postcard back. Photo postcards gave photographers a new customer base to expand their sales. These photographic postcards are known today as "real photos" and are usually less common than printed postcards because they were printed in small quantities. This book contains roughly 90 percent postcards (printed and real photo postcards) and 10 percent larger photographs.

In the winter of 1904–1905, the private Lake Placid Club started to promote winter sports to its members. At first, they tried cross-country skiing. Then came ice-skating, ski jumping, ice hockey, tobogganing, skijoring, harness racing on ice, and iceboating. The club was instrumental in bringing the Third Winter Olympic Games to Lake Placid in 1932. After the 1932 Olympics, the village of Lake Placid was synonymous with winter sports.

In order to avoid confusion, I have used the term *Lake Placid* to refer to the village of Lake Placid. I have used *Placid Lake* to indicate the five-and-a-half-mile lake next to the village. An Adirondack "camp" is a generic expression for a private home, a building, or a group of buildings in the woods or on a lake. By tradition, this camp can be the smallest lean-to or a giant mansion and is generally used as a residence.

Let us now go back in time and see what Lake Placid looked like before and after 1900. I hope you enjoy what you see.

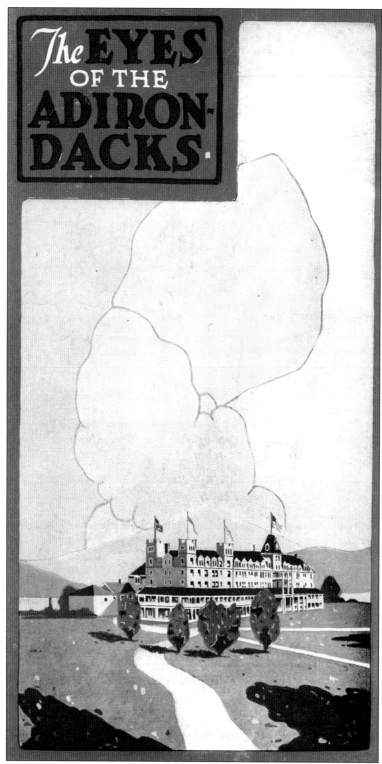

This beautiful illustration was created for the cover of a 20-page Stevens House brochure *c.* 1912.

One
LAKE PLACID VILLAGE

The Nash farm is shown in the early 1870s, when the land surrounding Mirror Lake consisted of only two farms. The buildings were located near the intersection of the present Saranac Avenue and Main Street. The Nashes started taking in "tourists" in the mid-1850s and soon added more rooms to house more guests. The original photograph was taken by S.R. Stoddard. (Eastern Illustrating Company, Belfast, Maine.)

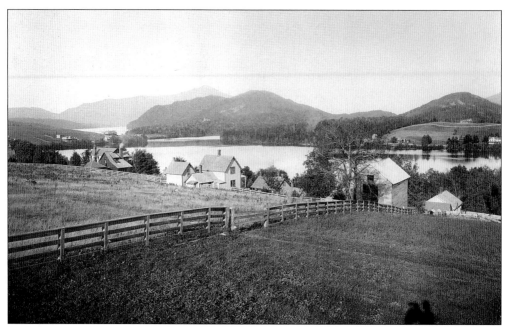

Looking toward Mirror Lake, this *c.* 1885 photograph was taken from the top of Grand View Hill. The houses in the foreground would be somewhat above Main Street. This lake was originally called Bennett's Pond in honor of the town of North Elba's first resident, Elijah Bennett.

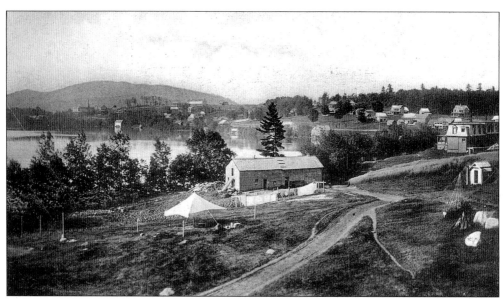

This view of the village looks toward Main Street *c.* 1890. The building in the foreground is the original Benjamin Brewster farmhouse, which was being used as a laundry for the first real hotel in the village, the Lake Placid House. The present Mirror Lake Inn would be to the right. (Illustrated Postcard Company, New York City.)

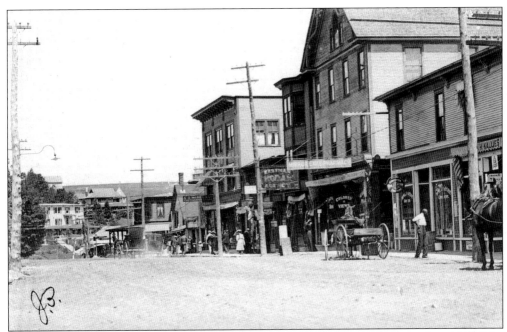

Main Street stores in the village are shown in this rare photograph looking north c. 1905. The photography store of W.F. Cheesman was located in the tall building. Just down the street was a photography store owned by Chester D. Moses, in the second building to the left of Cheesman's. Most of these buildings burned in a spectacular fire in 1919. Cheesman's building is still standing.

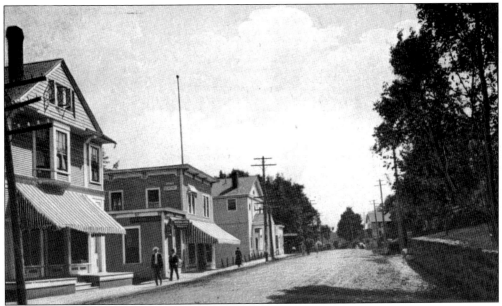

Looking south, this c. 1910 view shows Main Street before it was paved. (Hugh Leighton Company, Portland, Maine.)

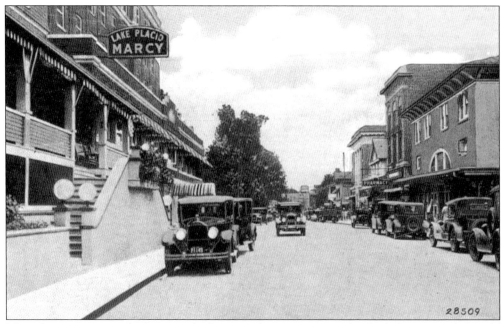

Main Street is pictured in a view looking north *c.* 1930. On the far left is part of the old Northwoods Inn, which became an annex to the Hotel Marcy. The Marcy, located just to the north, was completed in 1927. (Saranac Lake News Company, Saranac Lake.)

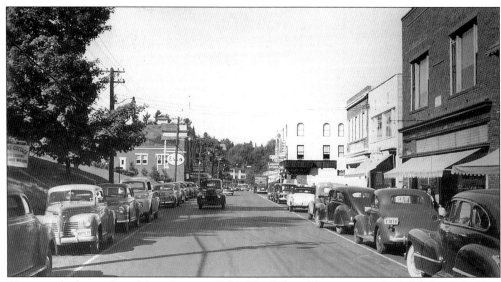

This view looks north up Main Street *c.* 1950. The Palace Theater is on the left behind the Esso gas station sign. Parking spaces were at a premium even then. ($5.00 Photo Company, Canton.)

Paul Stevens takes his young black bear
for a walk on Main Street *c.* 1925.
Stevens was one of the four Stevens
brothers. Their father was George
Stevens, owner of the famous Stevens
House, the largest hotel in Lake Placid.
(Photographer G.T. Rabineau.)

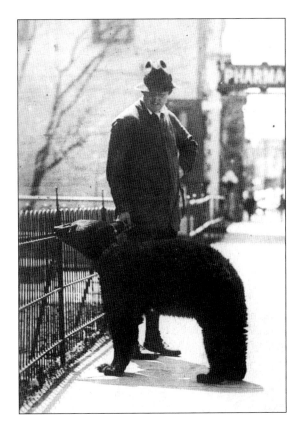

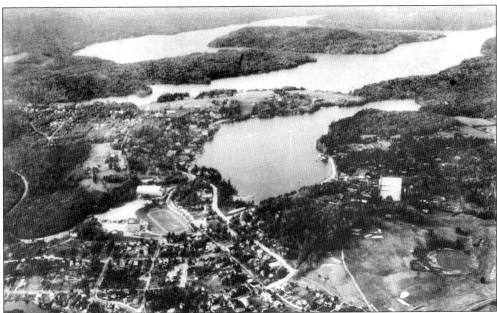

This *c.* 1935 view of the village and Placid Lake shows the narrow canoe carry between Mirror
and Placid Lakes. The white rectangle to the right of Mirror Lake shows tennis courts belonging
to the Lake Placid Club.

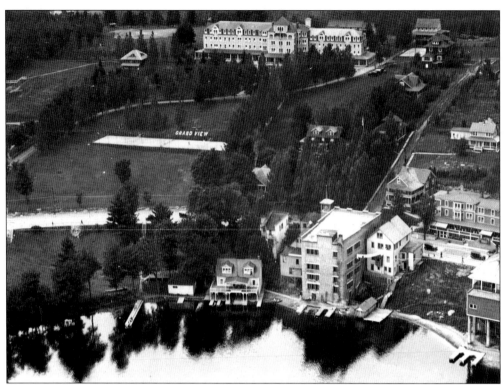

The south end of Main Street is pictured c. 1925. The Grand View Hotel, at the top of the hill, was replaced by the present Holiday Inn in the 1960s. The Northwoods Inn is on the far side of Main Street on the right.

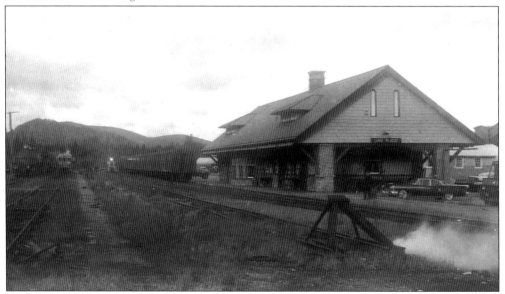

The first railroad passenger train of the Lake Placid & Saranac Lake Railroad arrived at Lake Placid in August 1893. The 10-mile line was later taken over by the Delaware & Hudson and, later, by the New York Central Railroad. The building now houses the Lake Placid and North Elba Historical Society. An excursion train runs to Saranac Lake and back today.

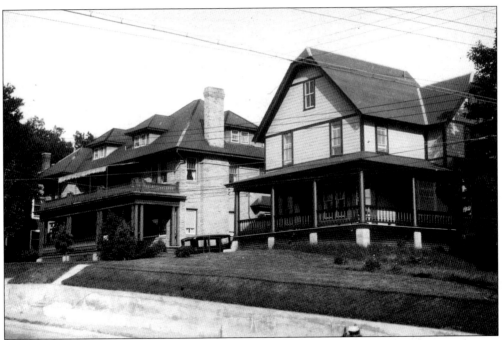

These buildings were located on the present Mirror Lake Drive. The building on the left was the residence of a Dr. Procter. In 1923, it became the Lake Placid General Hospital. The building on the right became a residence for nurses. The old hospital was razed in 1978 and is now the site of the National Sports Academy. (Photographer Eugene H. Pierson.)

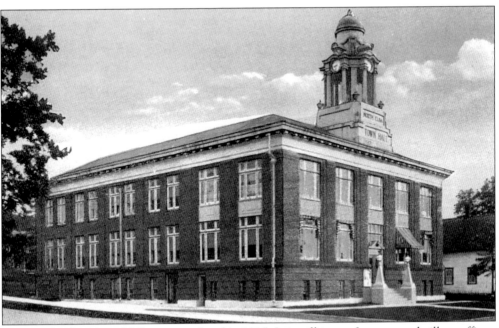

The North Elba Town Hall was completed in 1915. It is still in use for town and village offices. The building stands on lower Main Street opposite the 1932 Olympic speed-skating rink. (Tichnor Brothers Company.)

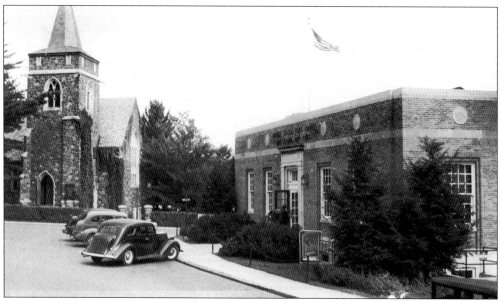

The Lake Placid post office was constructed in 1936. In this view, the Adirondack Community Church is on the left. The post office and church look virtually the same today. However, finding a parking spot at the post office today is a much greater challenge than it was in 1936. ($5.00 Photo Company of Canton.)

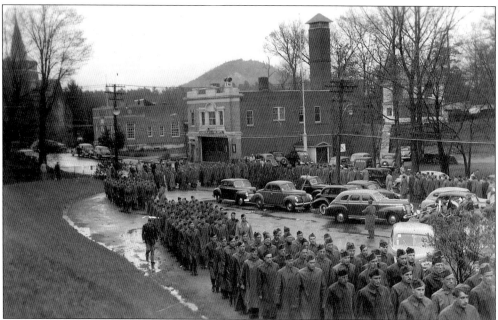

The Lake Placid Firehouse (with tower) is shown in the mid-1940s. The building is situated at the foot of Grand View Hill near the post office (to the left of the firehouse). Today, a ski shop occupies the building. In this view, a large group of soldiers is waiting to enter the 1932 Olympic Arena. In 1944 and 1945, soldiers were sent to the Lake Placid Club for rest and recuperation during World War II.

The old Lake Placid High School was located on Main Street on the site of the 1932 Olympic speed-skating rink. After the present high school was constructed, the building was cut into sections and moved to the Lake Placid Club. In this view, the school appears to be decorated for Lake Placid's Mid-Winter Carnival in 1914.

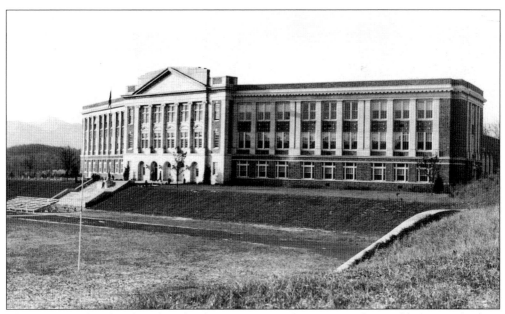

The present Lake Placid High School was constructed in 1922. A large addition was built in 1936. A speed-skating track was built in front of the school for the 1932 Olympics. It is still there today and is used for skating all winter long. The photograph was taken c. 1937.

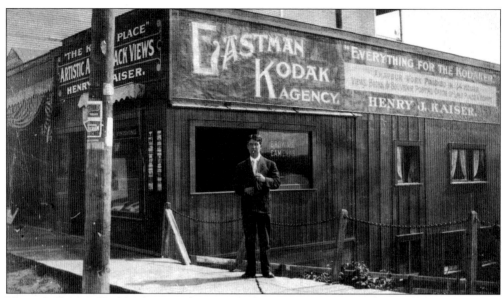

Henry J. Kaiser's Kodak photography store is shown *c*. 1905. It was located near the present band shell on Main Street. Kaiser bought out his partner James Brownell in 1901 and built up the business very quickly. He stayed in Lake Placid for about five years and moved on to the West Coast, where he became a world-famous industrialist. The building was torn down in 1909. The man in front of the store is not Kaiser.

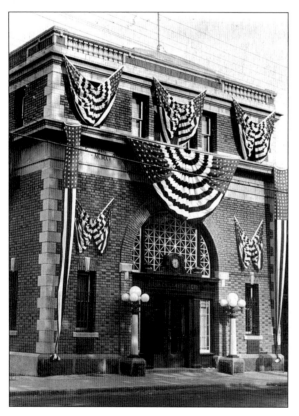

The Bank of Lake Placid is shown decorated for a parade *c*. 1930. Built in 1915 on Main Street, the building is still occupied by a bank today. (Photographer L. Fitch.)

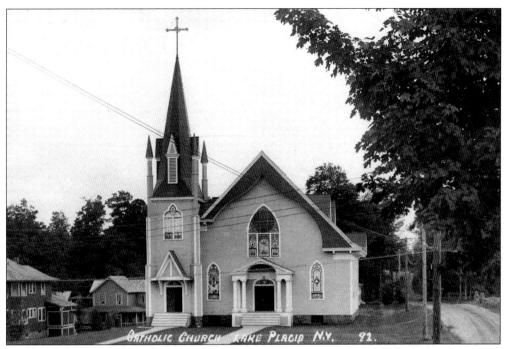

The old St. Agnes Catholic Church was located at the corner of Hillcrest and Saranac Avenues. This church was built in 1905 and was torn down to build the present St. Agnes Church. (Eastern Illustrating Company, Belfast, Maine.)

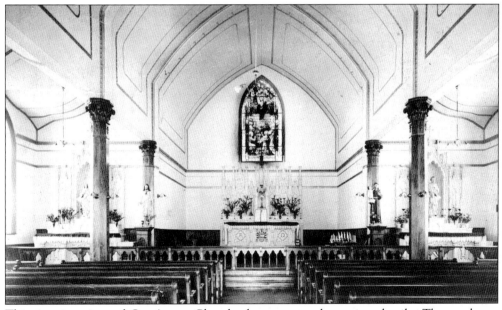

This interior view of St. Agnes Church shows many decorative details. The card was postmarked in 1909. (Photographer Chester D. Moses.)

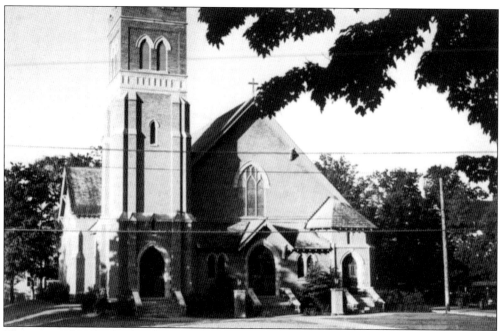

The present St. Agnes Church, shown *c.* 1932, was built in 1925. This time, it was constructed of brick.

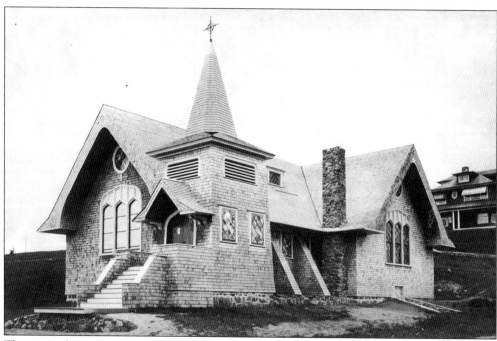

The original St. Eustace Episcopal Church, pictured *c.* 1920, was located at the foot of Signal Hill where Victor Herbert Road starts. The church was built in 1900 and was closed in 1922. In 1927, the building was then dismantled and rebuilt on Main Street with the tower on the opposite side. (Photographer Irving L. Stedman.)

Shown in this *c.* 1918 postcard is the original Baptist church on Main Street. The present Baptist church is located on Saranac Avenue. (Eastern Illustrating Company, Belfast, Maine.)

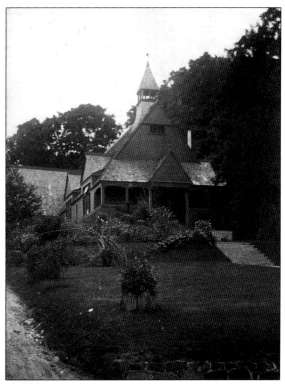

The Adirondack Community Church was opened in 1925. It is located on Main Street, on the shore of Mirror Lake near the post office.

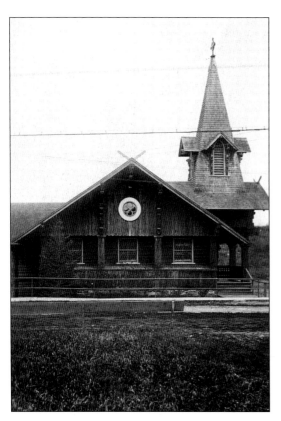

St. Huberts Episcopal Church, shown *c*. 1925, was located in the area called Newman, south of Mill Hill. The church became the Pilgrim Holiness Church in the 1920s and burned in the 1950s. It was rebuilt and is still the Pilgrim Holiness Church. (Photographer G.T. Rabineau.)

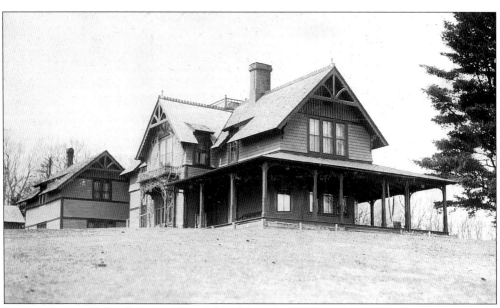

The residence of John Stevens is located on Main Street. Stevens was owner of Lake Placid's largest hotel, the Stevens House. The house is the second oldest on Main Street and later became the rectory of the St. Eustace Episcopal Church. The card was postmarked in 1907.

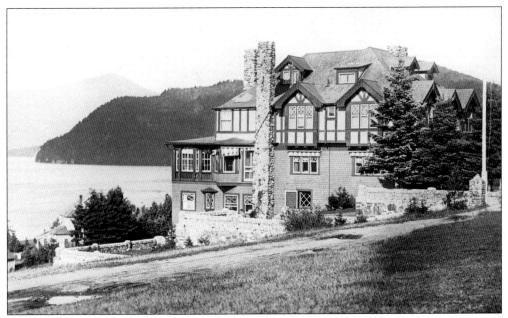

The house known as High Knoll, overlooking Placid Lake, is located at the crest of Victor Herbert Drive. In the 1920s, it was the summer home of Wall Street stock market trader Jesse Livermore. Violinist Ephram Zimbalist also vacationed there. It was also known as the Placid Shore Inn. (Photographer G.T. Rabineau.)

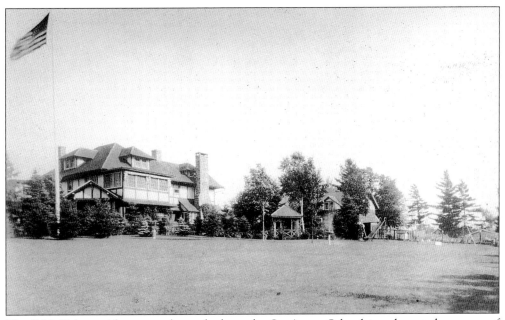

The S.H. Kahn residence was located where the St. Agnes School is today, at the corner of Hillcrest and Saranac Avenues. The building was purchased by the church in 1944 and was used for some years as a parish house. It was demolished in 1957, when the school was built. The house was originally owned by Soloman Lowenstein.

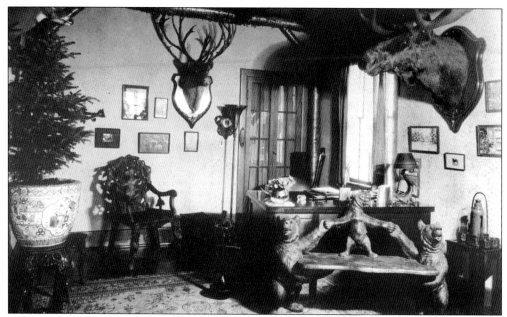

Kahn decorated his house with hunting trophies and Black Forest wood carvings, as was done in rustic camps. Yellow-birch logs were also used as trim. This was somewhat unusual, as the house was in a residential part of the village.

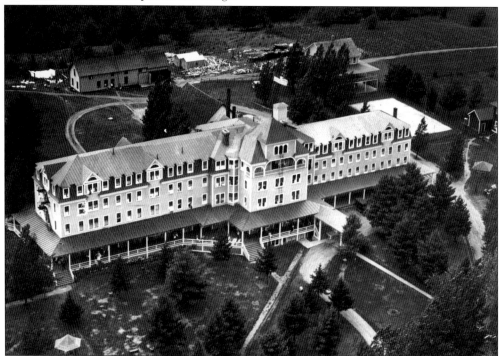

The Grand View Hotel was Lake Placid's second largest. The hotel was built in 1878 and was enlarged over the years. It sat at the top of a hill, overlooking Mirror Lake. The glorious view was considered to be one of the best in the Adirondacks. The present Holiday Inn replaced the Grand View after it was torn down in 1961. (Publishers Photo Service, New York City.)

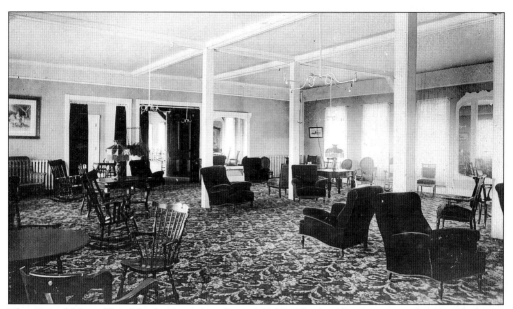

The Grand View Hotel had a formal parlor in 1910. The hotel was very posh, considering it was located in an Adirondack Mountain village. (Photographer H.M. Beach, Remsen.)

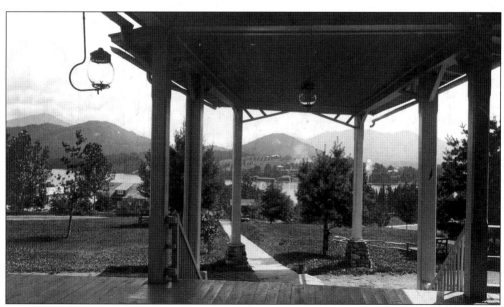

This *c.* 1910 view of Mirror Lake and Cobble Hill was taken from the porte-cochere of the Grand View Hotel. This is where the carriages and stagecoaches unloaded passengers for the hotel. Outdoor gaslights were still in use at this time. (Photographer H.M. Beach, Remsen.)

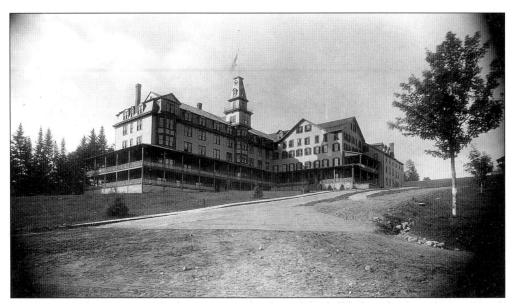

The Mirror Lake House was built in 1882 at the foot of the hill below the Grand View Hotel. In 1894, the building burned to the ground and was never rebuilt. Later, the hill was partially removed to build the main village parking lot. (Photographer Sipperly, Balston Spa.)

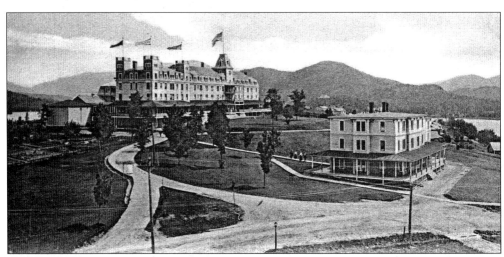

The Stevens House was located on the top of Signal Hill. The hotel could accommodate 400 guests in all of its buildings. In 1900, a popular golf course was constructed on the grounds. The magnificent view of the lakes and mountains was one of the best in the Adirondacks. This c. 1900 view was taken near Saranac Avenue. (Rotograph Company, New York City.)

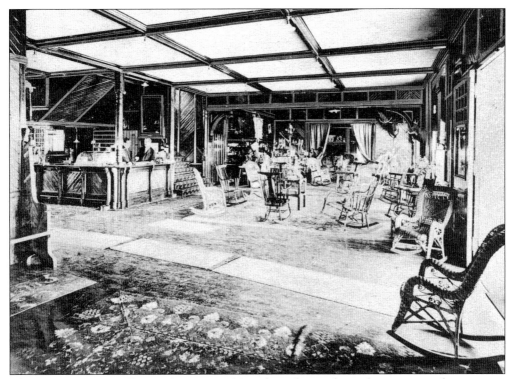

The Stevens House office is shown *c.* 1900 with wicker rocking chairs waiting for guests to arrive. The hotel opened for business in 1886. In 1889, electricity was added, which was generated at the hotel's own plant. (National Art Views Company, New York City.)

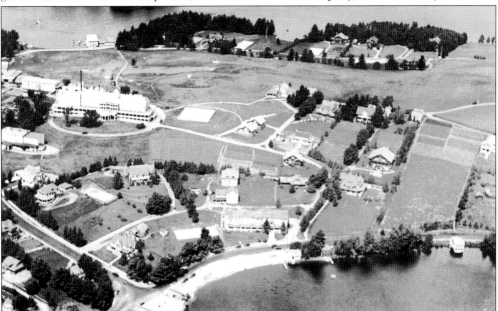

The Stevens House and Signal Hill are shown in this *c.* 1935 aerial view. The Stevens brothers had been selling building lots for some time and, by 1930, the hill had many grand summer homes built on it. (Photographer Roger Moore.)

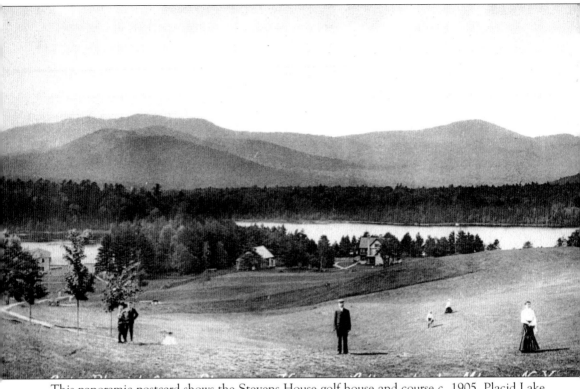

This panoramic postcard shows the Stevens House golf house and course *c.* 1905. Placid Lake is behind the trees, and Whiteface Mountain is on the right in the distance. John Dunn was

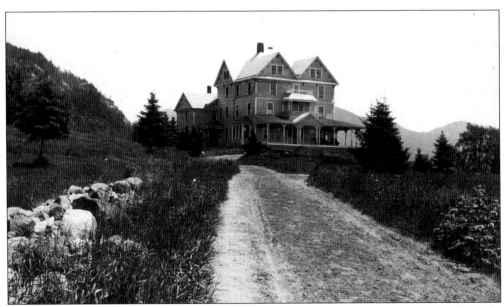

The Forest View House, shown *c.* 1920, was located at the top of the hill overlooking the Lake Placid Club. The hotel was built *c.* 1895 and was run by W.H. Bennett. The Lake Placid Club bought the hotel in 1925, and it burned in 1944. Cobble Hill is seen to the left.

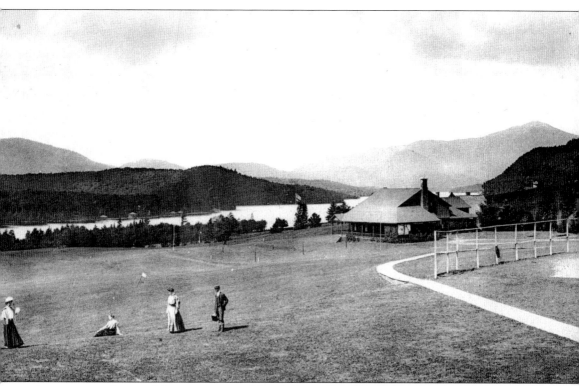

the course professional for many years. Noted Scottish golfer Willie Dunn was his uncle. (Rotograph Company, New York City.)

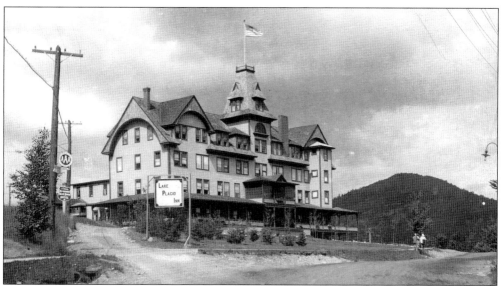

The Lake Placid House was the first real hotel to be built in the village. It was built in 1871 by Benjamin Brewster on land near the carry between Mirror and Placid Lakes. The name was later changed to the Lake Placid Inn. Heavily modified and enlarged in the late 1890s, it burned to the ground in 1920 and was not rebuilt. (Eastern Illustrating Company, Belfast, Maine.)

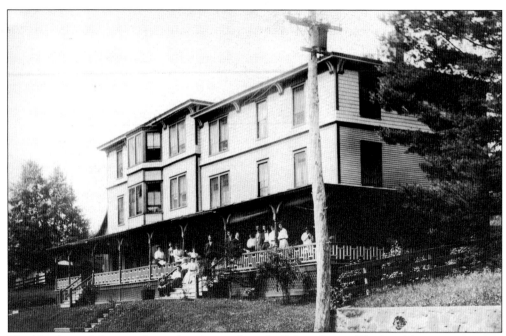

The Northwoods Inn was located at the south end of Main Street. The hotel became an annex to the Hotel Marcy when the Marcy was built next door. The annex burned in 1966. In this view, people are posing on the veranda *c.* 1915.

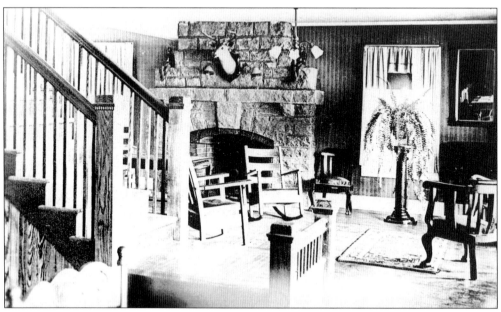

This interior view of the Northwoods Inn is dated 1917. The room appears to be a sitting room for visitors and hotel guests. The hotel offices and front desk were located to the left of the stairs. The furnishings were much simpler than those at the Grand View Hotel. (Photographer Irving L. Stedman.)

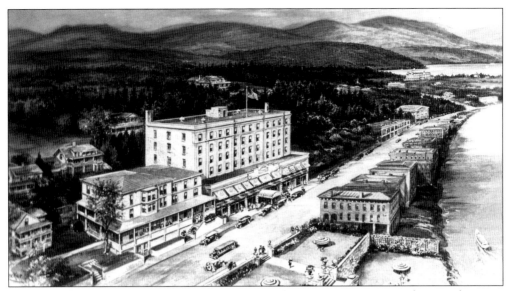

The Hotel Marcy and Main Street buildings are shown in an artist's rendering. The artist somehow forgot to include the Alford Inn, a competing hotel just next door. The Marcy was completed in July 1927 and was the village's first "fireproof" hotel. (Photographer G.T. Rabineau.)

The Lakeside Inn was situated close to the shore of Mirror Lake near the beginning of Saranac Avenue. The Ramada Inn complex occupies the site today. (Santway Photo-Craft Company, Watertown.)

The Marshall Maloy residence was built in 1880 on Main Street and still stands next to the Northwoods Inn. It is the oldest existing building on Main Street. In 1925, it was more than doubled in size and converted to a hotel called the Alford Inn.

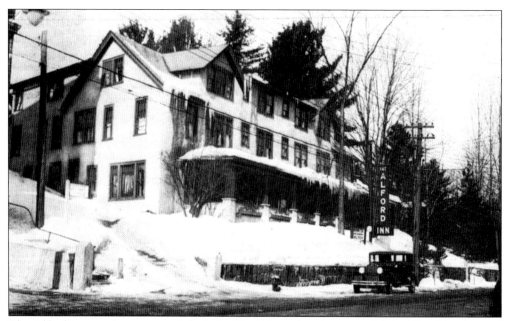

The Alford Inn was later renamed the Lake Placid Inn after the original Lake Placid Inn burned in 1920. The lawn in front was later removed, and a direct entrance to Main Street was constructed. A large rustic furnishings store occupies the building today. (Santway Photo-Craft Company, Watertown.)

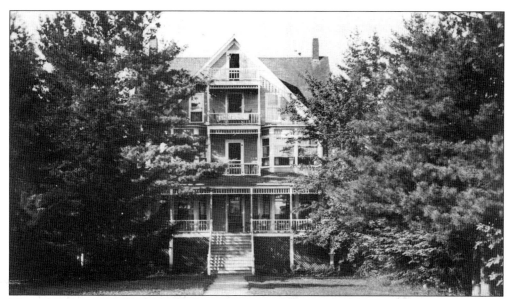

The small Pines Hotel was located on the west side of the hill on Saranac Avenue. It was renamed the St. Moritz Hotel *c.* 1924. (Photographer G.T. Rabineau.)

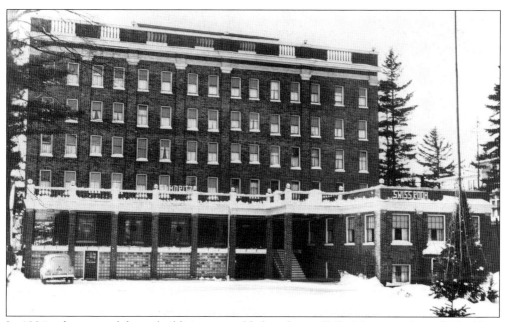

In 1924, a large wood-framed addition was added to the small St. Moritz, making the building five stories high. Later, a brick facade and restaurant addition were added to make it look more substantial. ($5.00 Photo Company, Canton.)

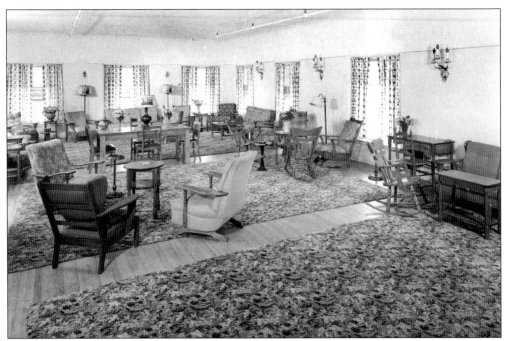

The St. Moritz morning room is shown *c.* 1950. This room looks like a comfortable place for guests and friends to relax.

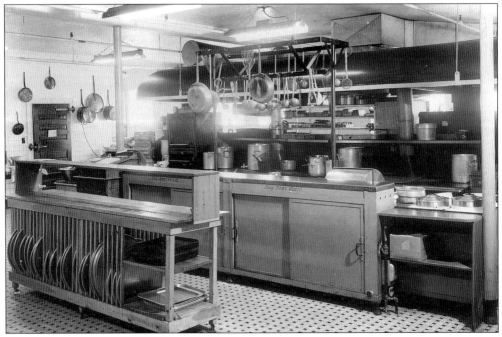

Pictured *c.* 1950 is the well-equipped kitchen of the St. Moritz Hotel. Local restauranteur Goodman Kelleher bought the hotel in 1943 and renovated it.

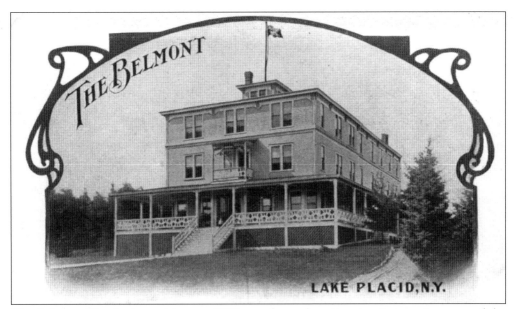

The Belmont Hotel, pictured here *c.* 1907, was located on Saranac Avenue just west of the St. Moritz Hotel.

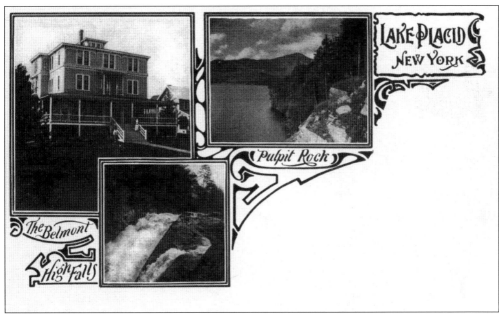

This artistic postcard from the Hotel Belmont dates from *c.* 1905. It shows the hotel with a view of Pulpit Rock on Placid Lake and High Falls at Wilmington Notch, a few miles east of the village.

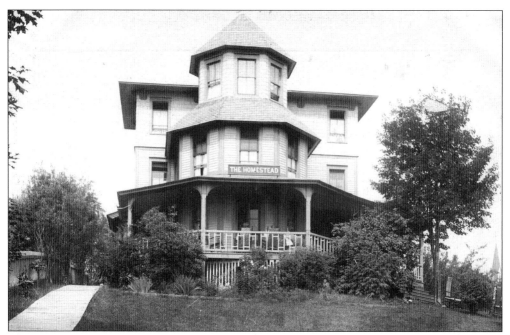

The Homestead Hotel was located on Main Street near the beginning of Saranac Avenue. This card, postmarked in August 1908, reads, "We are very lazy, shall be getting fat. Will see Ausable Chasm on the way home."

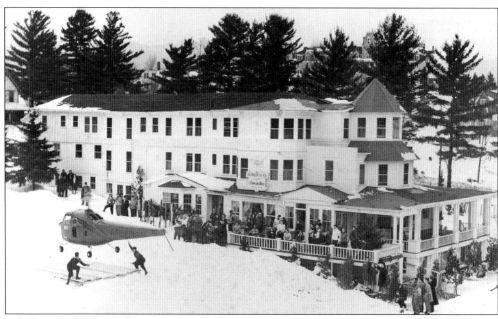

A helicopter lands on the snow-covered lawn of the Homestead Hotel *c.* 1945. (Photographer Bob Gobrecht, Mountainville.)

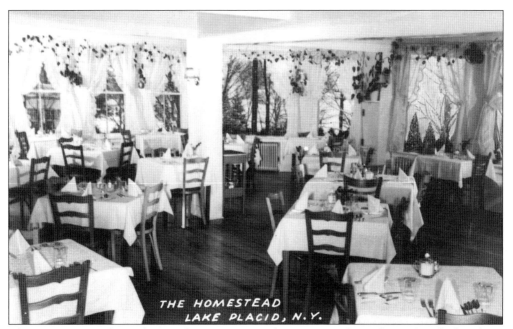

This interior view shows the popular restaurant at the Homestead Hotel *c.* 1950. The hotel was demolished in 1978 to build the present Hilton Hotel.

The Mirror Lake Inn was originally called Mir-a-lak Inn. The popular inn, which overlooked the lake, was expanded over the years and burned in 1988. It was rebuilt and remains today as one of the village's most popular hotels. (Albertype Company, Brooklyn.)

A Mirror Lake Inn cottage, on the shore of Mirror Lake, was a great place to relax and take in the exquisite mountain scenery. The card is postmarked September 1941. (Photographer Grover Cleveland.)

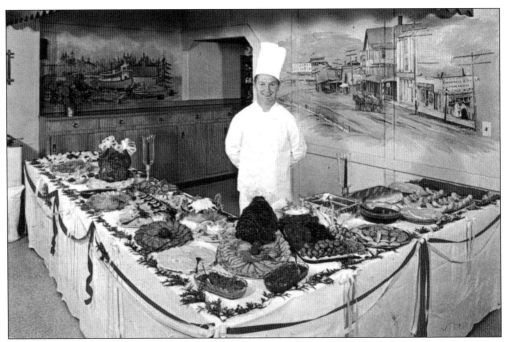

This beautiful buffet at the Mirror Lake Inn was offered c. 1960. Over the years, the hotel has won awards for its cuisine. Note the murals depicting early village scenes. (Hannau-Robinson, New York City.)

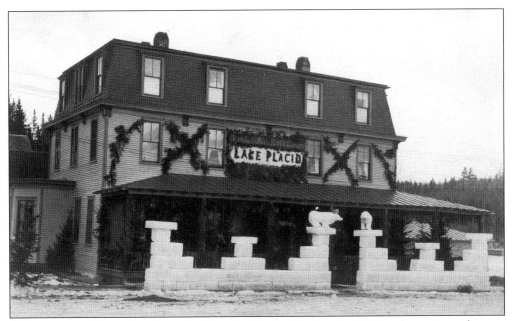

The American House Hotel was built by the Hurley Brothers in 1893 and was situated across the street from the railroad station in the Newman section of the village. The hotel burned in 1941. Ice sculptures decorate the entrance c. 1920.

The Brewster Cottage was a small tourist house on the outskirts of the village near Mill Hill. The house was owned by Byron Brewster, who was village mayor from 1904 to 1908. The house burned in 1941. (Eastern Illustrating Company, Belfast, Maine.)

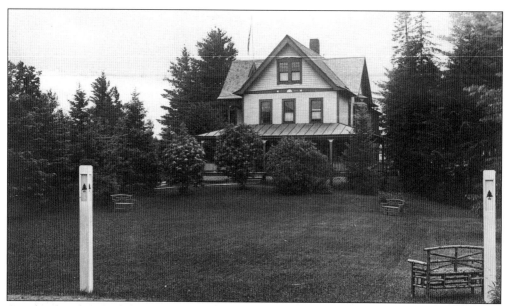

Another hotel named the Pines Inn was located just up the hill from the St. Moritz Hotel on Saranac Avenue *c.* 1930. Located next door to the St. Agnes School, it is now a funeral home and has had some additions over the years. (Eastern Illustrating Company, Belfast, Maine.)

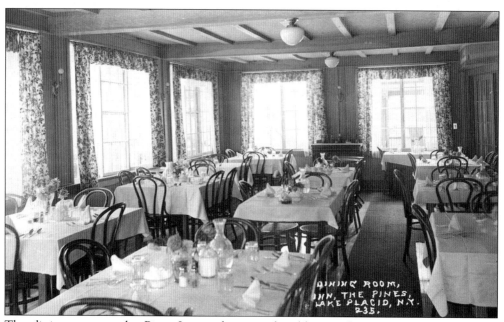

The dining room at the Pines Inn is shown with tables set for guests *c.* 1930. (Eastern Illustrating Company, Belfast, Maine.)

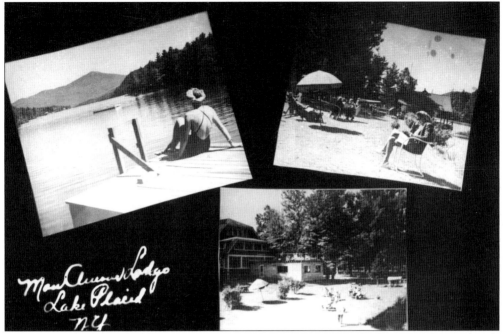

This photo postcard shows three views of the Mon Amour Lodge, which was on the north side of Saranac Avenue. Its property extended down to Paradox Bay on Placid Lake, where the hotel had a beach. Condominiums occupy the property today.

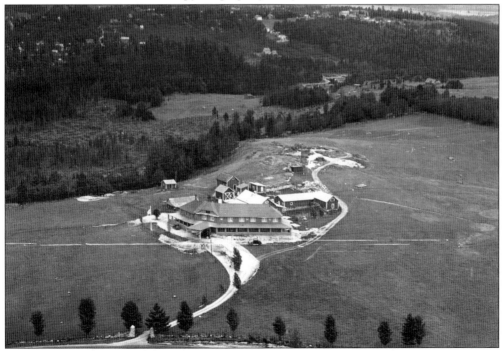

The Fawn Club lodge and golf course opened in 1921. Shown *c.* 1925, it was later called the Alpine Lodge and Motel. The lodge was razed in the 1960s, and the Alton Jones Cell Science Center was constructed. (Publishers Photo Service, New York City.)

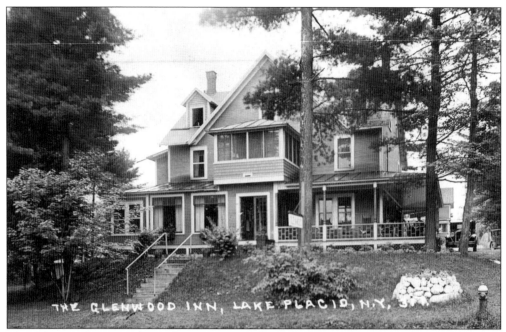

The Glenwood Inn was located on Greenwood Street. The Greenwood Senior Apartments occupy the site today. (Eastern Illustrating Company, Belfast, Maine.)

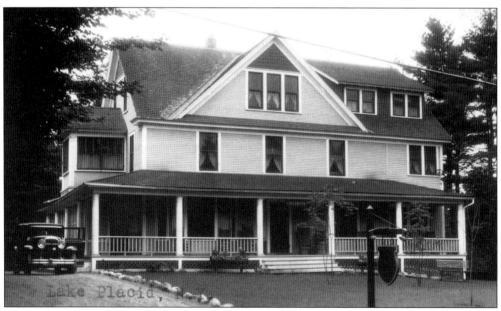

Cheesman's Olympic Inn was located at 39 Saranac Avenue. The building, shown c. 1930, is still standing and became an annex to the St. Moritz Hotel in the 1950s.

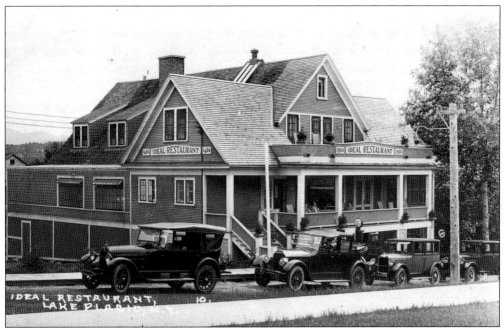

This building was first built on upper Main Street as a Methodist church in 1888. In 1923, it was moved to a location on School Street near Main Street. It was then enlarged and converted to a restaurant called the Ideal. It was also known as the Campus and, later, the Olympic Restaurant. Today, the Mud Puddles nightclub occupies the building. (Eastern Illustrating Company, Belfast, Maine.)

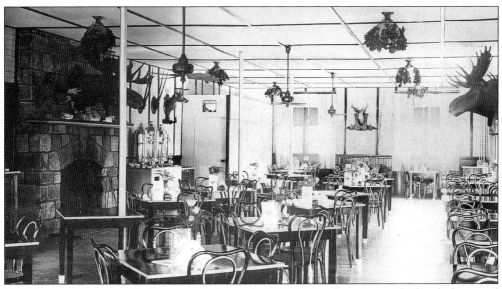

The Campus Restaurant dining room is pictured *c.* 1930. Many hunting trophy heads decorated the walls. (Eastern Illustrating Company, Belfast, Maine.)

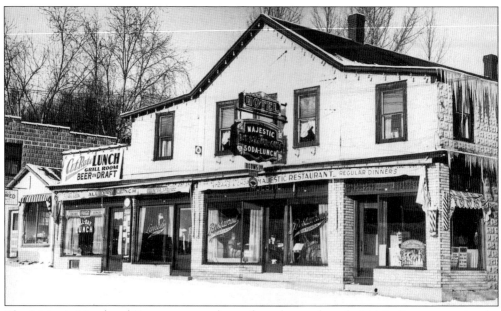

The Majestic Hotel and Restaurant was located on the south end of Main Street opposite the Olympic oval skating rink. Owner Goodman Kelleher later modernized the building and added a brick facade. The site is now occupied by a parking lot.

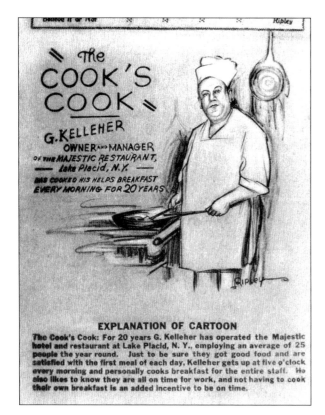

Believe It or Not — Ripley

The COOK'S COOK

G. KELLEHER
OWNER AND MANAGER OF THE MAJESTIC RESTAURANT, Lake Placid, N.Y.
HAS COOKED HIS HELPS BREAKFAST EVERY MORNING FOR 20 YEARS

Ripley

EXPLANATION OF CARTOON
The Cook's Cook: For 20 years G. Kelleher has operated the Majestic hotel and restaurant at Lake Placid, N. Y., employing an average of 25 people the year round. Just to be sure they got good food and are satisfied with the first meal of each day, Kelleher gets up at five o'clock every morning and personally cooks breakfast for the entire staff. He also likes to know they are all on time for work, and not having to cook their own breakfast is an added incentive to be on time.

The Majestic's owner, Goodman Kelleher, was written up in *Ripley's Believe It or Not* in 1938. His claim to fame was that he personally cooked breakfast for the restaurant employees for 20 years.

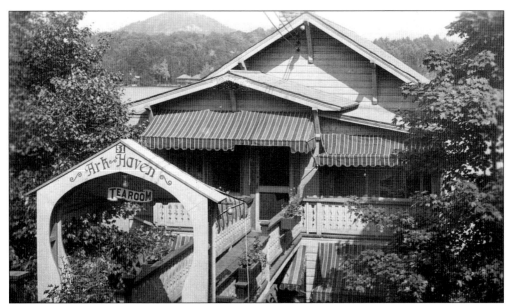

The Ark Haven Tea Room was located on Main Street, overlooking Mirror Lake near the present village band shell. Shown in a mid-1930s photograph, it was a restaurant that served light breakfasts and lunches.

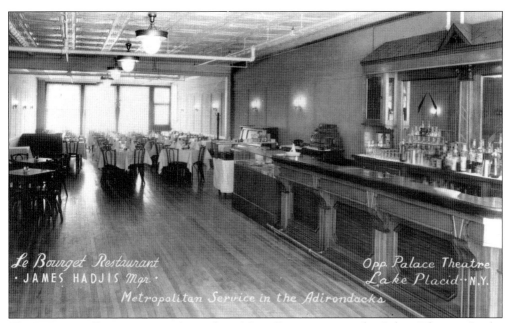

The LeBourget Restaurant was located on Main Street opposite the Palace Theater. In the summer, it had a popular open-air dining room overlooking Mirror Lake.

STEVENS HOUSE,

LAKE PLACID. N.Y.

Monday, July 2, 1917

BREAKFAST

Strawberries and Cream

Grape Fruit — Oranges

Stewed Rhubarb — Preserved Figs — Stewed Prunes

Hominy

Post Toasties — Force — Shredded Wheat

Broiled Salt Salmon

Eggs

Boiled, Fried, Scrambled, Poached, Shirred or Omelette

Premium Bacon or Ham — Calf's Liver — Stew Kidney

Corned Beef Hash — Sirloin Steak

Premium Sausage — Lamb Hash — Lamb Chops — Broiled Tripe

Potatoes: Lyonaise, Baked or Hashed in Cream

Wheat Cakes, Maple Syrup

Parker House Rolls — Graham Rolls — French Rolls

Dry or Buttered Toast

Corn Muffins — Milk Rolls — Fried Hominy — Crescents

Tea — Coffee — Milk — Cocoa

MEAL HOURS

Breakfast, 7 to 9:30 — Luncheon, 12:30 to 2 — Dinner, 6 to 8

Sunday — Breakfast, 8 to 10 — Dinner, 1 to 2 — Supper, 6 to 7:30

This printed breakfast menu from the Stevens House hotel is dated July 2, 1917. The menu was changed daily, and it would seem that the management offered an eclectic variety of foods for each meal.

Two

MIRROR AND
PLACID LAKES

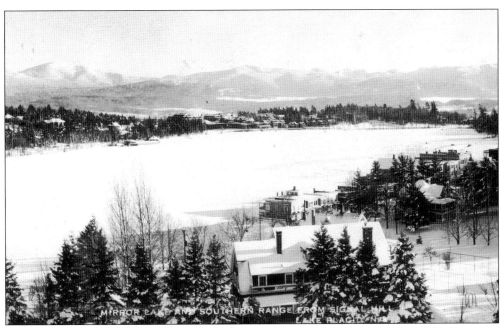

Taken from Signal Hill, this photograph shows a frozen Mirror Lake *c*. 1945. The Southern Range is in the distance.

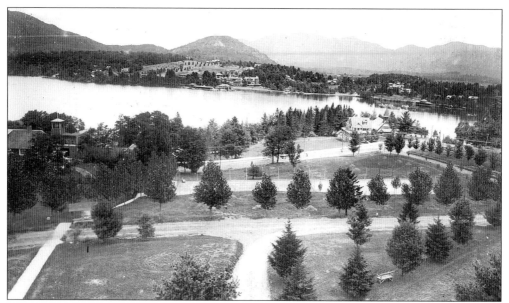

The south end of Mirror Lake and the Lake Placid Club (on the opposite shore) are shown c. 1910. The photograph was taken from the Grand View Hotel. (Photographer H.M. Beach, Remsen.)

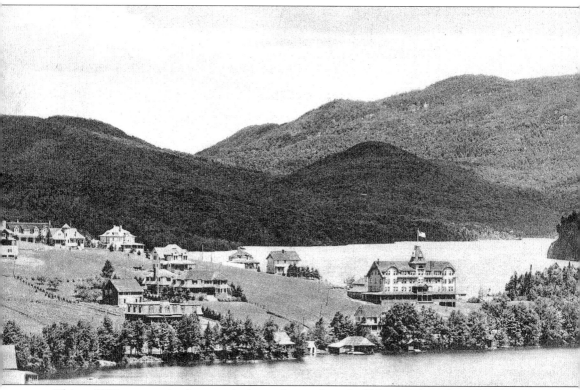

This c. 1907 panoramic photograph shows the north end of Mirror Lake. The Lake Placid Inn sits at the bottom of Signal Hill on the left, flying a flag from its tower. Whiteface Mountain is

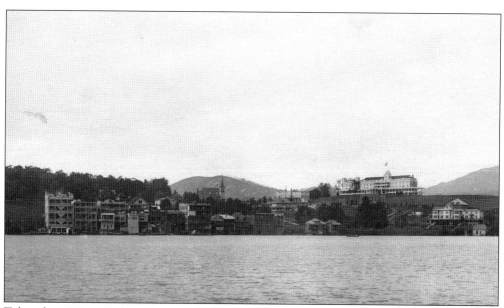

Taken from Mirror Lake, this *c.* 1920 photograph offers a view of the backs of stores on Main Street and shows the Stevens House on the top of Signal Hill. On the far right is the Lakeside Inn, at the edge of the lake. (Eastern Illustrating Company, Belfast, Maine.)

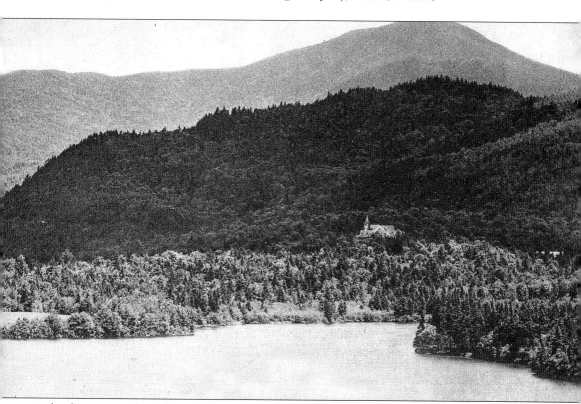

in the distance on the right.

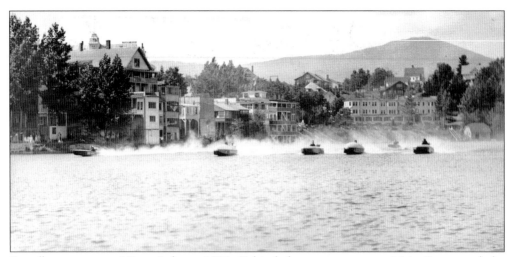

Speedboats race on Mirror Lake *c.* 1930. Behind them are stores on Main Street and the Lakeside Inn (right). Today, motorboats are not normally allowed on the lake.

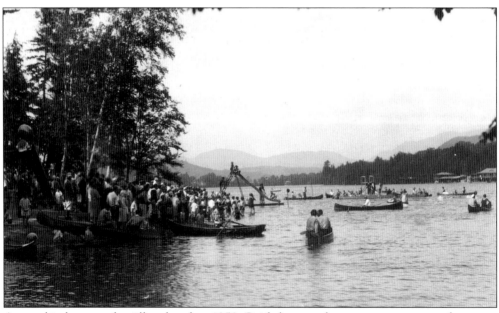

A crowd is shown at the village beach *c.* 1950. Guide boats and canoes congregate on the water.

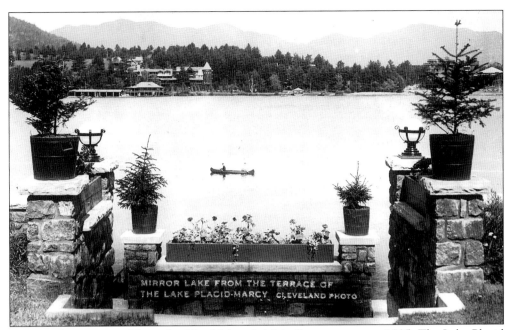

Mirror Lake is pictured from the Hotel Marcy's Main Street terrace *c.* 1935. The Lake Placid Club's Lakeside complex is on the opposite shore. (Photographer Grover Cleveland.)

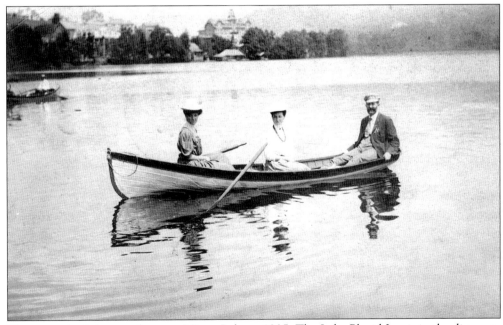

Three people sit in a rowboat on Mirror Lake *c.* 1905. The Lake Placid Inn is in the distance.

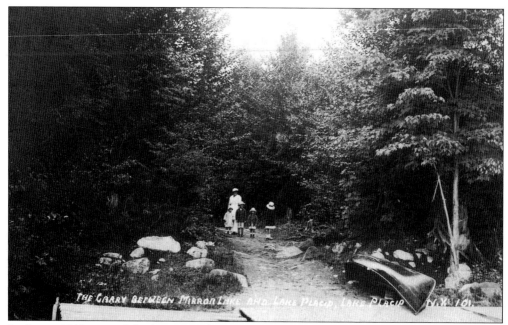

In this *c.* 1918 view of the boat carry between Mirror and Placid Lakes, a guide boat sits near the wooden launching platform.

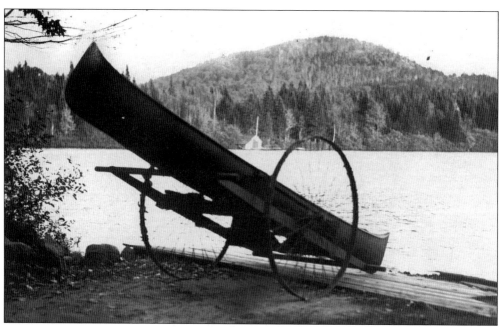

A canoe rests on the cart at the Mirror Lake side of the boat carry *c.* 1920. The cart was used to transport the boats between Mirror and Placid Lakes. (Photographer G.T. Rabineau.)

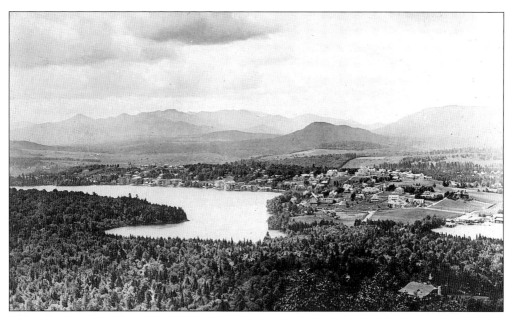

This photograph, taken from Mount Whitney, shows Signal Hill, Mirror Lake, and the Southern Range *c*. 1920. (Photographer G.T. Rabineau.)

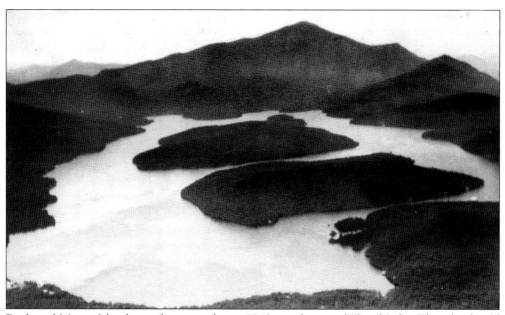

Buck and Moose Islands are shown in this *c*. 1940 aerial view of Placid Lake. The islands add miles to the total shoreline. (Photographer Grover Cleveland.)

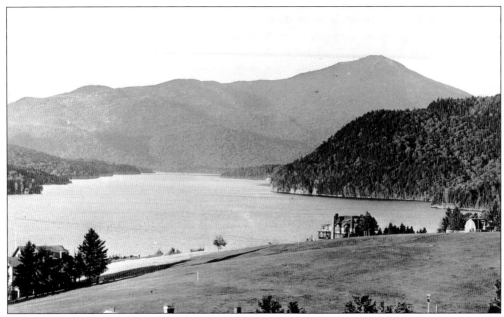

This photograph was taken from the Stevens House c. 1925. The view shows a portion of the hotel golf course, the east half of Placid Lake (known as the East Lake), and Whiteface Mountain. (Photographer G.T. Rabineau.)

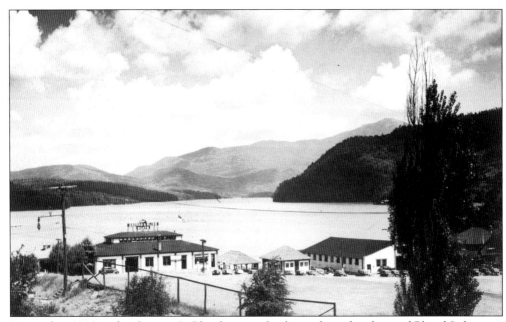

Pictured c. 1938 is the George & Bliss boat works, located on the shore of Placid Lake near the carry.

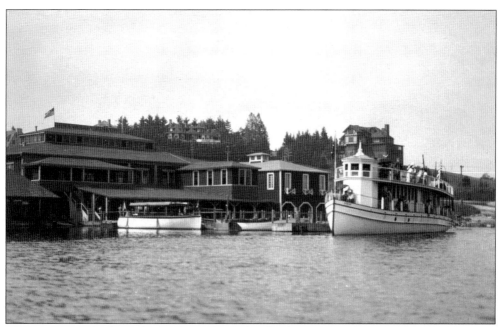

The George & Bliss boat shop is shown from Placid Lake *c.* 1930. The venerable passenger and U.S. mail boat *Doris* is at its dock.

A young tourist poses for the camera near Paradox Bay on Placid Lake in 1898.

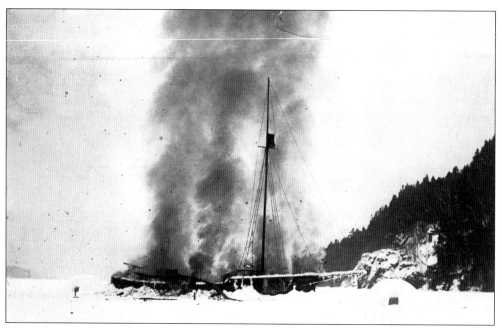

This February 1920 photograph shows a mock-up of a sailing ship burning on Placid Lake during the filming of the silent movie *Out of the Snows*. Pulpit Rock can be seen to the right. Quite a few films have been made in and around Lake Placid over the years. (Photographer G.T. Rabineau.)

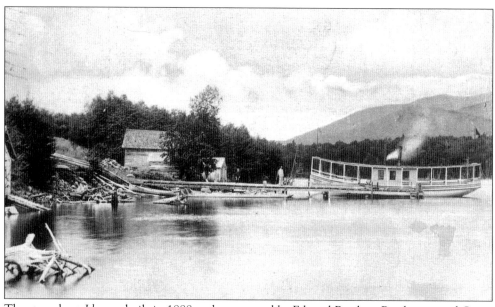

The steamboat *Ida* was built in 1888 and was owned by Edward Bartlett. Bartlett owned Camp Pinafore on the West Lake. The dock was situated at the foot of Signal Hill on the East Lake. (Illustrated Postcard Company, New York City.)

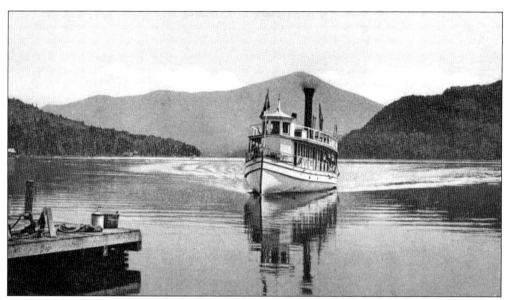

In this *c.* 1905 view, the steamboat *Doris* approaches a dock on Placid Lake, with Whiteface Mountain in the distance. (Detroit Publishing Company, Detroit, Michigan.)

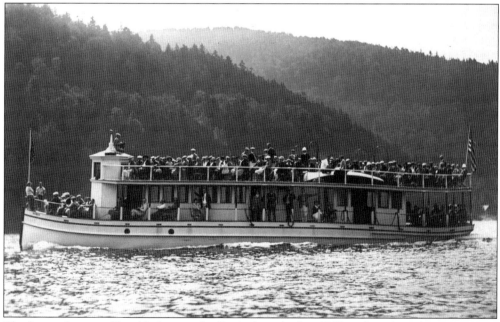

The largest boat on Placid Lake was the *Doris,* launched in 1898 and used until its retirement in 1950. The *Doris* picked up and delivered passengers traveling to the private camps and hotels on the lake. The mail was also delivered by the boat. A large group of passengers is shown enjoying the day *c.* 1930.

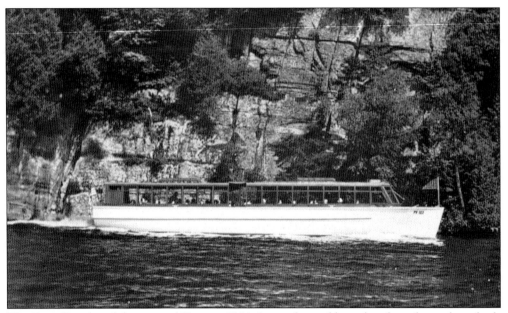

The *Doris II* replaced the original *Doris* in 1951. It was shipped by railroad as a kit and was built at the George & Bliss boat works. (Barton Press.)

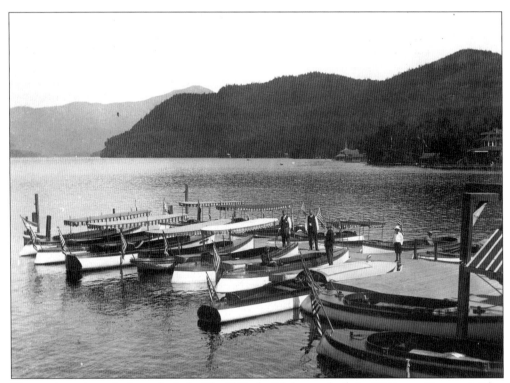

These private boat docks at the Lake Placid Yacht Club were built in 1907 near George & Bliss on the East Lake. The card is postmarked 1910.

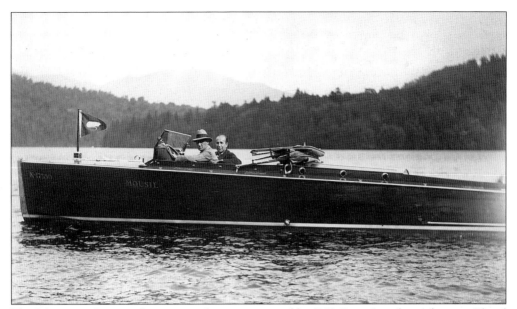

The *Mousie*, a classic mahogany runabout, was owned by C.H. Low. It is shown here on Placid Lake *c*. 1932. (Photographer G.T. Rabineau.)

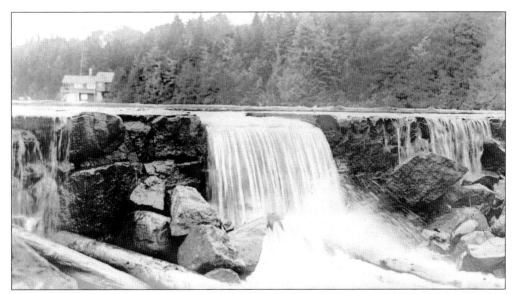

The outlet dam at the southern end of the West Lake is pictured *c*. 1925. The dam had to rebuilt every few years to repair ice and storm damage.

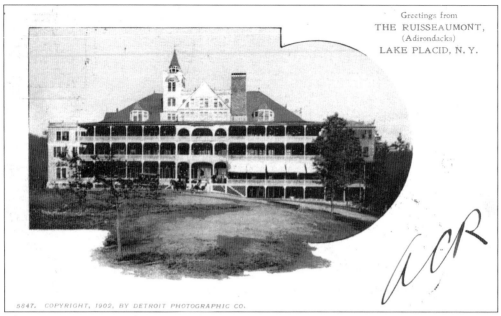

The Ruisseaumont Hotel was erected in early 1892 on the East Lake not too far from Pulpit Rock. The hotel burned on July 2, 1909, and was not rebuilt. The next year, a Jewish group bought the hotel grounds, and private homes were built on the site. (Detroit Publishing Company, Detroit, Michigan.)

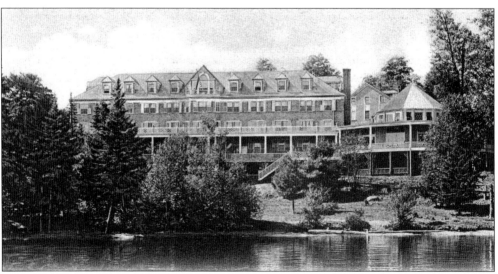

Pictured is the original Whiteface Inn, built in 1901 on the West Lake. This building was erected on the site of an earlier hotel called the Westside. The Whiteface Inn burned on May 20, 1909. (Rotograph Company, New York City.)

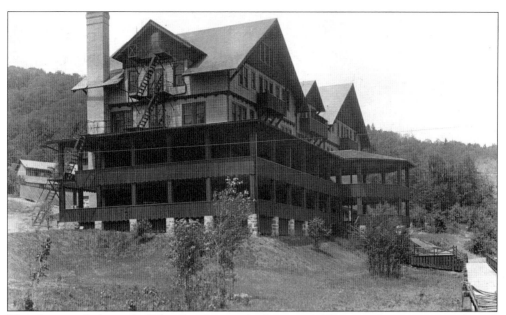

This photograph shows the Whiteface Inn as rebuilt in 1915. (Photographer Irving L. Stedman.)

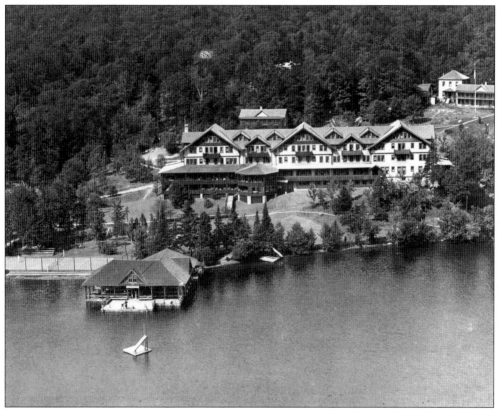

The Whiteface Inn is shown in an aerial photograph c. 1925. In 1916, an addition was added that almost doubled the size of the hotel. (Publishers Photo Service, New York City.)

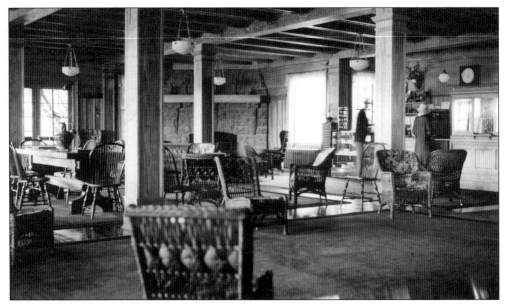

The rebuilt Whiteface Inn lounge is shown in 1915. The post office with the Whiteface designation is at the right. The room is decorated in a casual manner. The previously popular Victorian style was now quite outdated. (Photographer Irving L. Stedman.)

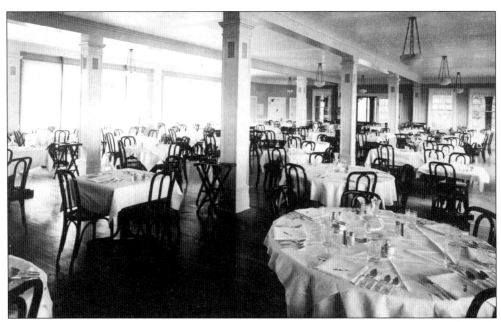

Pictured c. 1915 is the main dining room at the Whiteface Inn. The hotel was razed in the early 1980s. A large condominium complex stands in its place. (Photographer Irving L. Stedman.)

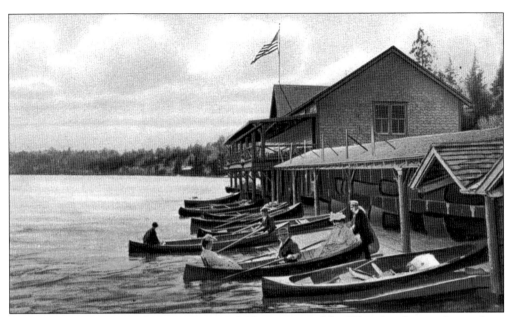

Numerous guide boats and canoes were available to guests of the Whiteface Inn, and many boat regattas were held over the years. This c. 1907 image shows the original Whiteface Inn boathouse. (A.C. Bosselman Company, New York City.)

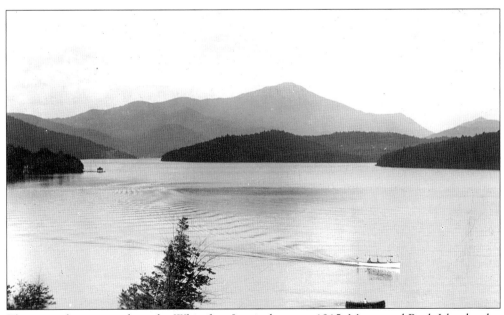

The magnificent view from the Whiteface Inn is shown c. 1915. Moose and Buck Islands, plus Whiteface Mountain, are in the distance. (Photographer Irving L. Stedman.)

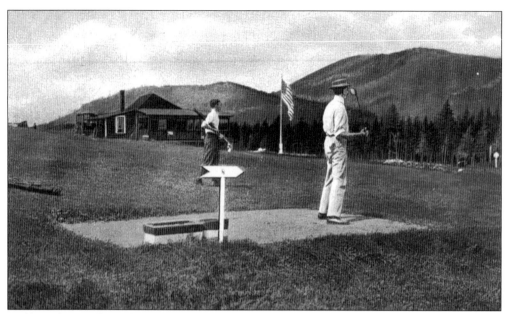

Golfers play at the Whiteface Inn course *c.* 1908. Great mountain vistas made the game pleasurable even if the score was high. (A.C. Bosselman Company, New York City.)

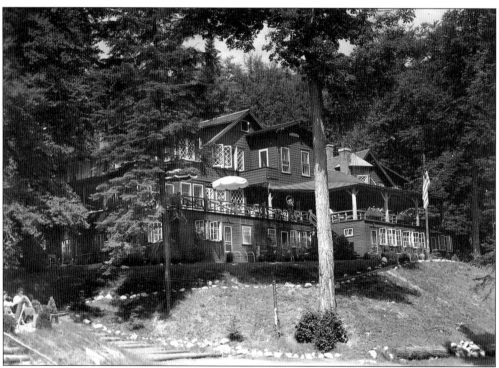

This view of Placid Manor dates from *c.* 1950. The property had been previously known as Camp Coosa since 1916. It was enlarged and became a hotel in 1946. The new owners called it Placid Manor. Later, the name was changed to Lake Placid Manor. Major alterations and additions were made in the mid-1990s, and it is now called Lake Placid Lodge.

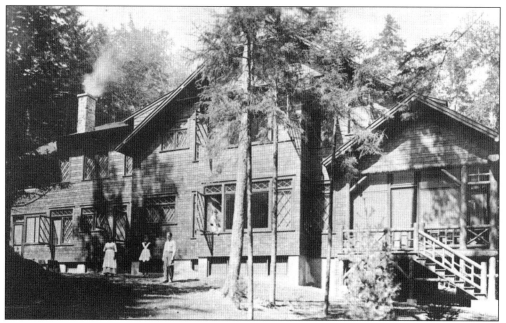

Camp Kaytonah was built in 1916 on the West Shore and was located next to Camp Midwood. It was later known as Rockledge and owned by Max Kaufman.

The Moosehead Lodge Club (previously known as Camp Shawandassee) was used as a small resort hotel in 1946–1947. It is now known as Camp Menawa on the West Shore. (Albertype Company, Brooklyn.)

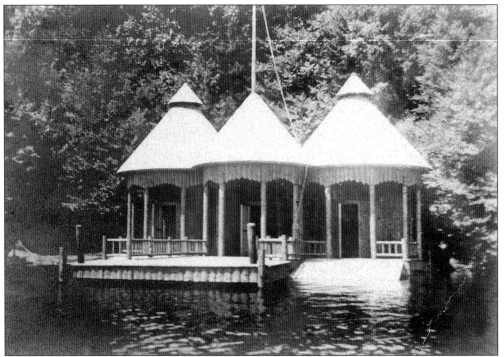

This unusual boathouse was located at Nytis Lodge, which was owned by Frederick Wait and located on the West Shore. The card was postmarked in 1905 and is signed by Wait's wife, Mary Monell Wait. She was the person who named Mirror Lake in the 1870s. The camp still exists, sans boathouse, and is now called Sunnyside Nytis Lodge.

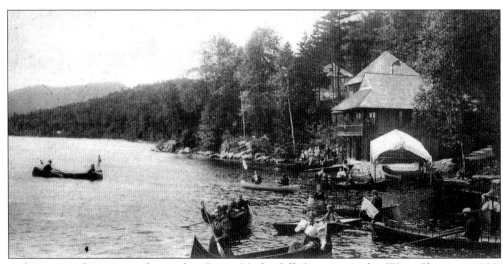

A busy waterfront view shows the Camp Undercliff Casino on the West Shore c. 1909. Undercliff was built by Charles Loring Brace in the early 1880s. The camp was later used as a hotel, music camp, and New York Central Railroad retreat camp for executives. Many original buildings still remain. (Rotograph Company, New York City.)

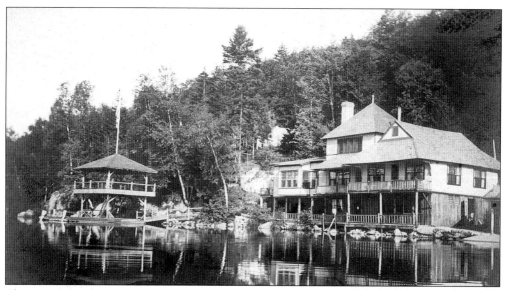

This *c.* 1915 image offers a later view of the Camp Undercliff Casino. A combination summerhouse and boat dock is to the left. The Camp Undercliff Casino has been restored and looks very much the same today.

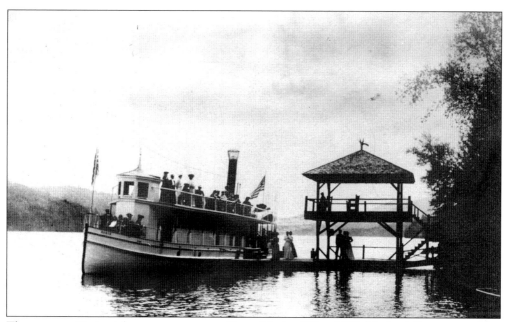

The steamer *Doris* picks up passengers at Camp Undercliff *c.* 1909. Undercliff was one of the camps farthest from Lake Placid village.

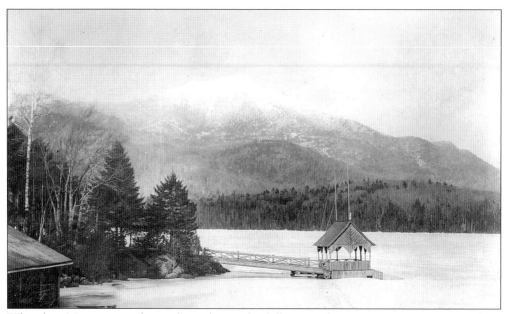

Whiteface Mountain is shown from the Undercliff summerhouse in winter. (Photographers Stedman and Lockwood.)

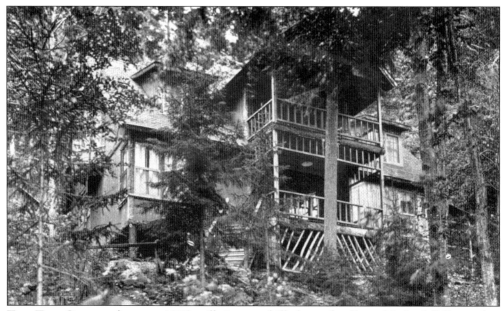

Tree Tops Cottage, shown *c.* 1925, still sits on a hill above the Camp Undercliff Casino but needs total restoration.

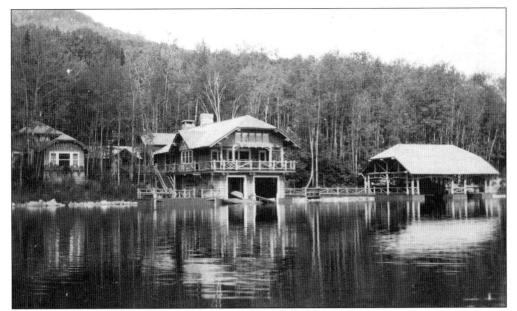

Camp Eagles Eyrie, built in 1905, was owned by Calvin Pardee. This camp was the farthest one from the village and was located in Echo Bay at the north end of Placid Lake. It was later owned by the Erdman family. The buildings are gone, and the property is now state-owned land.

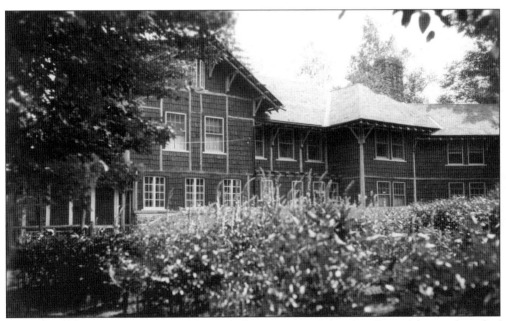

Camp Birchwood was built by Harrie T. Hull in 1910 on Whiteface Bay at the north end of Placid Lake. The camp was later bought by the Uihlein family, who were partners in the John Eichler Brewing Company in New York City. Later, it became a summer camp. The state eventually obtained the land, and the buildings were burned.

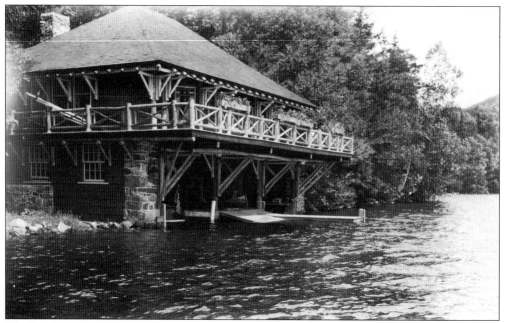

The boathouse at Camp Birchwood is pictured c. 1930. The camp had a great close-up view of Whiteface Mountain.

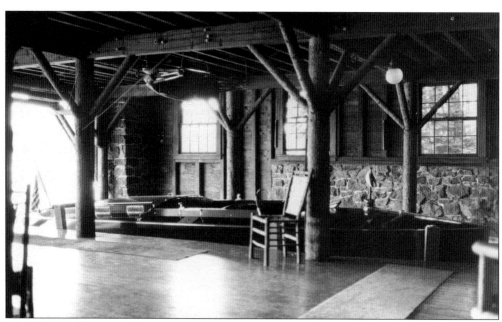

This image offers an interior view of the boathouse at Camp Birchwood c. 1930. The long, triple-cockpit wooden boat is probably a Chris-Craft. The boathouse is now gone, but the broken cement-lined slips are still there, as is the stone foundation of the rambling main house.

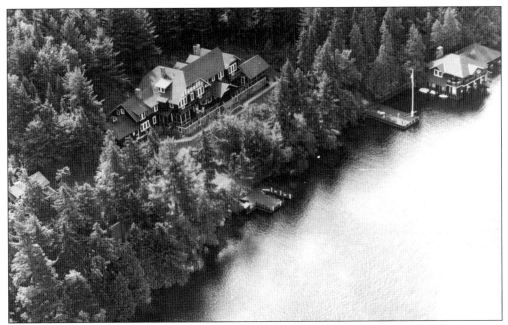

Camp Carolina, on the east shore of Placid Lake, was built for Caesar Cone in 1913. Cone was a North Carolina textile manufacturer. The camp featured a funicular railway to bring supplies up the lawn from the dock. The card is postmarked 1958.

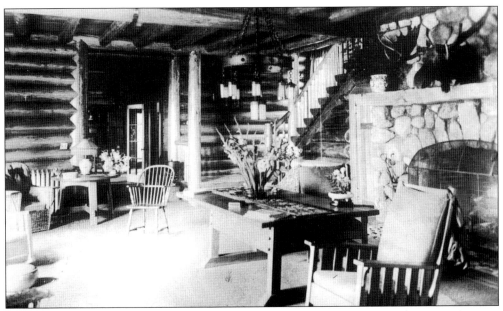

The Camp Carolina main house interior was constructed of whole logs. In this c. 1935 image, the stone fireplace is adorned with a moose head. Unlike all other east shore camps, there was originally no road into this camp. However, a road was constructed in the late 1990s. (Photographer Roger Moore.)

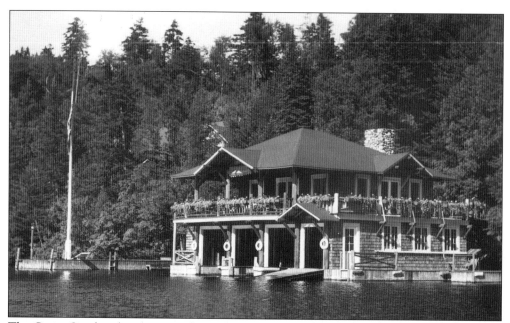

The Camp Carolina boathouse is shown *c.* 1935. An addition was later constructed to house more boats.

A woman enjoys the porch at Camp Gordon on the east shore of Placid Lake *c.* 1930. She is sitting in a Westport-style Adirondack chair.

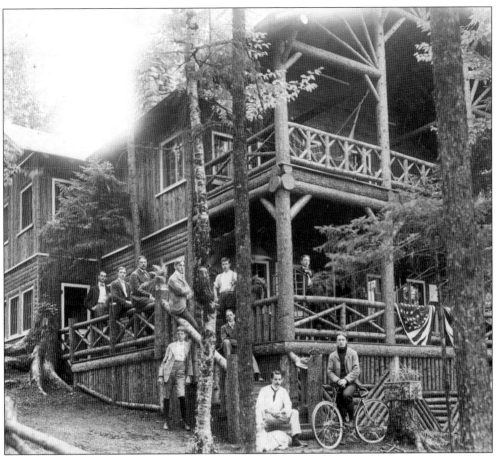

The main house of Camp Irondequoit is pictured *c*. 1901. The building was erected *c*. 1900 on the east shore of Placid Lake for Rev. William Moir. The camp was used to provide spiritual and physical recreation for boys. Moir was instrumental in building the first St. Eustace church. (Photographer W.F. Cheesman.)

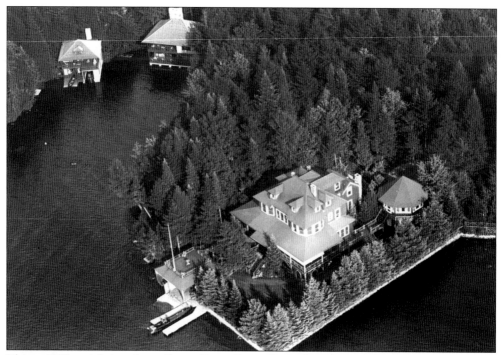

This *c.* 1930 aerial view shows Breezy Point Camp, located on the east shore. In 1912, the camp was built by Herbert Wolfe. Seymour A. Strauss bought the camp in 1918. (Publishers Photo Service, New York City.)

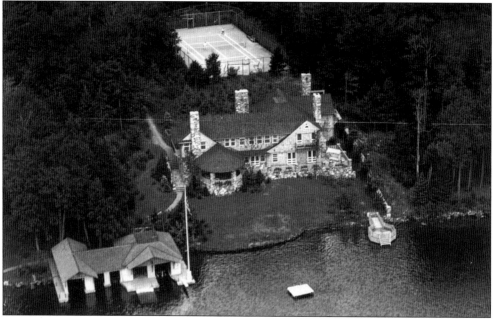

Renata-on-the-Lake, shown *c.* 1930, was owned by Dr. Bart Ring. This peninsula camp was built for A.W. Popper in 1917 and called Camp Wateaminit. It later became Maria Renata, a retreat for Catholic nuns. The main house was demolished in 1995. (Publishers Photo Service, New York City.)

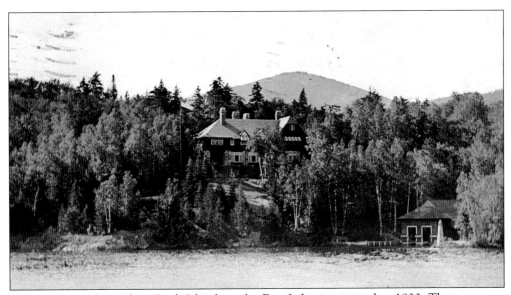

Camp Kiwanis, located on Buck Island on the East Lake, is pictured *c.* 1930. The camp was built by Bessie Benson Emerson in 1915. Emerson changed the name to High Wall in 1924. Just visible on the right in front of the boathouse is Placid Lake's only lighthouse, which is still in use today. (Photographer G.T. Rabineau.)

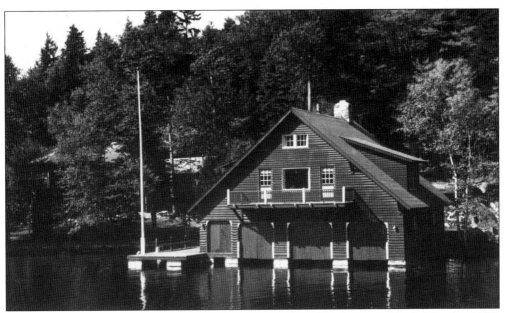

This view shows entertainer Kate Smith's Camp Sunshine boathouse on Buck Island *c.* 1950. The camp is still located on Sunset Strait but is painted white. Smith broadcasted her weekly radio program from the boathouse in the summer. The camp was originally owned by R.F. Norton and called Camp Sunset.

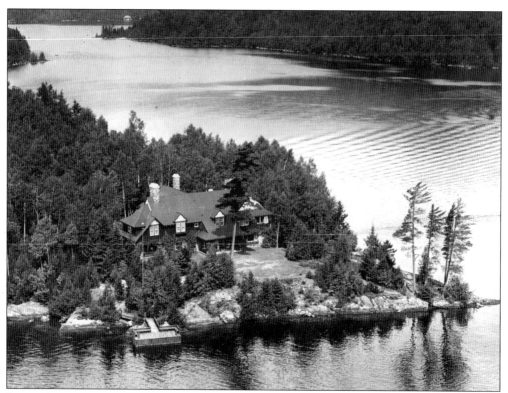

Pictured *c.* 1925, Camp Majano on Buck Island was owned by W.S. Benson. It still has a prominent location on Cape Marie at the east end of Shelter Strait. (Publishers Photo Service, New York City.)

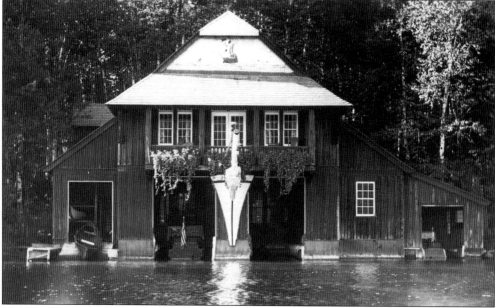

The boathouse at Camp Majano was built in 1915. Shown *c.* 1935, it is in better condition today than it was at that time. (Photographer Roger Moore.)

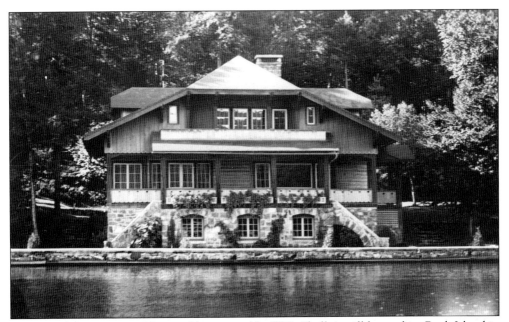

The main house at Camp Unterwalden, owned by W.E. Shell, is still located on Buck Island in the Shelter Strait. The camp was originally called Camp Canadohta.

The porch of the main house at Camp Indian Point is shown c. 1930. The camp was built in 1906 and owned by J.B. Dimmick. The building burned in 1946 and was not rebuilt.

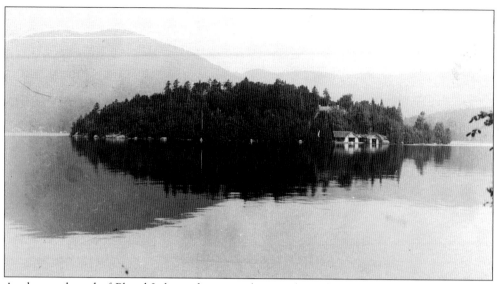

At the north end of Placid Lake is the privately owned Hawk Island Camp. The P.C. Fuller family owned it at the time this photograph was taken *c.* 1935. (Photographer W.F. Cheesman.)

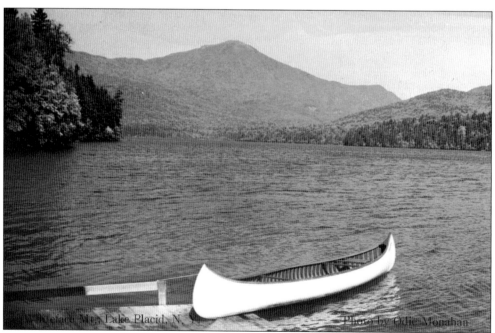

This *c.* 1935 photograph of Whiteface Mountain was taken from the east shore of Moose Island. Adirondack views do not get much better than this. (Photographer Odie Monahan.)

Three
WINTER SPORTS

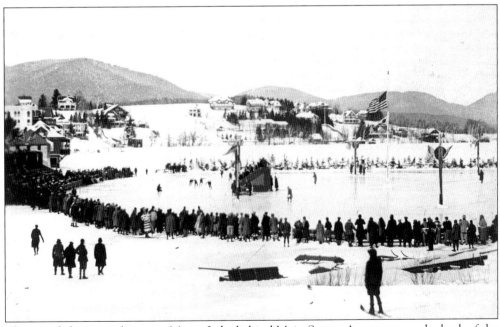

This speed-skating rink was on Mirror Lake behind Main Street. A message on the back of the image reads, "Feb. 1925—International Skating Races on Mirror Rink." Ice-skating races of various kinds were held for many years and were a popular winter pastime. The houses in the distance are on Signal Hill. (Photographer G.T. Rabineau.)

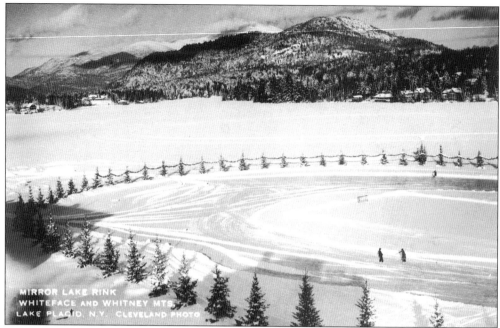

Mirror Lake is shown decorated with evergreen trees *c.* 1935. An ice hockey rink has been set up on the right. (Photographer Grover Cleveland.)

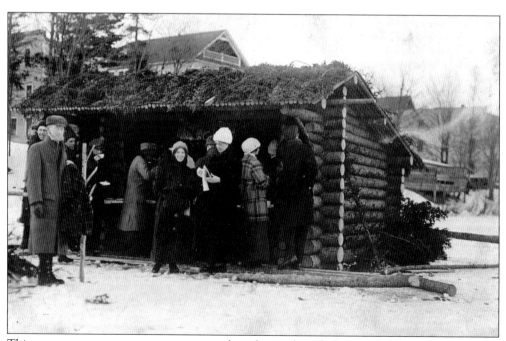

This temporary open camp was constructed on the south end of Mirror Lake for a winter event *c.* 1925. Refreshments are being served inside. (Photographer Irving L. Stedman.)

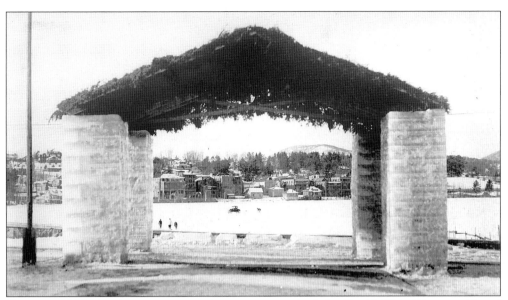

Shown *c.* 1935, this decorative ice arch was set up at the Lake Placid Club. The rear sides of Main Street buildings can be seen across Mirror Lake. (Photographer Grover Cleveland.)

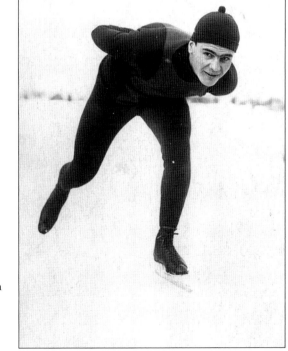

Lake Placid native Charles Jewtraw is pictured in 1921. Jewtraw was a great speed skater and won many championships in the 1920s. He was the first person in the world ever to win a Winter Olympic medal. He won that gold medal (500-meter speed skating) at Chamonix, France, on January 26, 1924. (Photographer G.T. Rabineau.)

81

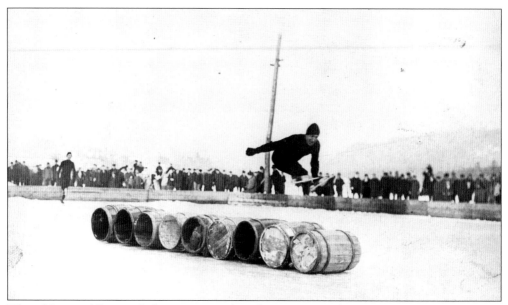

Edward Lamy of Saranac Lake jumps nine barrels on Mirror Lake *c.* 1920. Lamy was a famous champion speed and exhibition skater. The author owns a similar photograph of Lamy jumping 12 barrels.

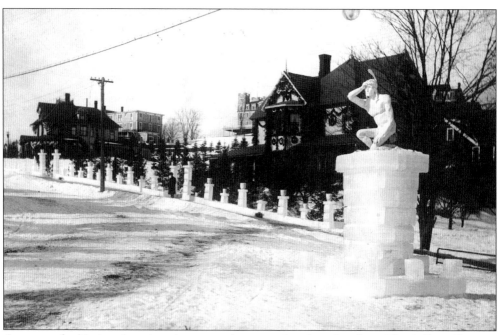

A statue of a Native American is mounted on a pedestal made of ice. The hill on Saranac Avenue is decorated with more ice pedestals a few yards away. These decorations were made for the Mid-Winter Carnival at Lake Placid in 1914. (Photographer Irving L. Stedman.)

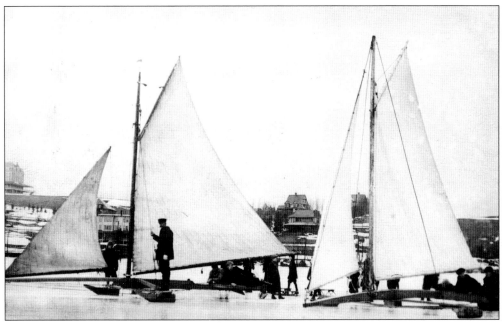

Two iceboats are shown on a frozen Mirror Lake *c.* 1915. They had about one mile to traverse on the lake from end to end. The houses between them in the background are on Signal Hill. The boaters have attracted a group of children, who are probably hoping for a ride. (Photographer Irving L. Stedman.)

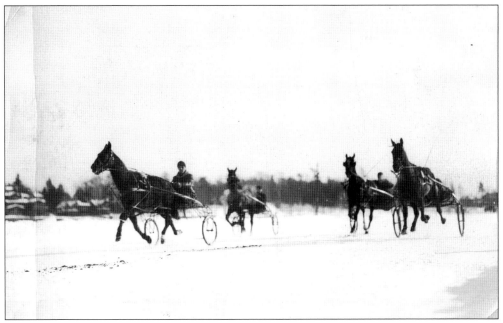

Trotting horses race on Mirror Lake *c.* 1932. Winter harness racing on the ice was a popular pastime for many years. (Photographer Eugene H. Pierson.)

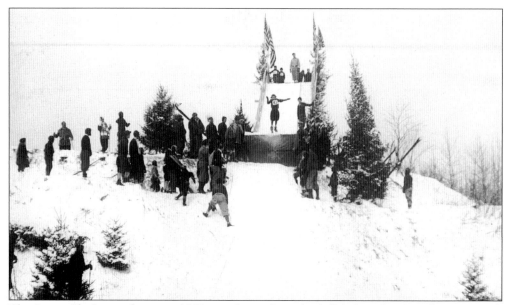

The Junior Ski Jump, shown c. 1930, was located on the hill below the Grand View Hotel. Young skiers would get their first taste of jumping at this site near Main Street. (Photographer Grover Cleveland.)

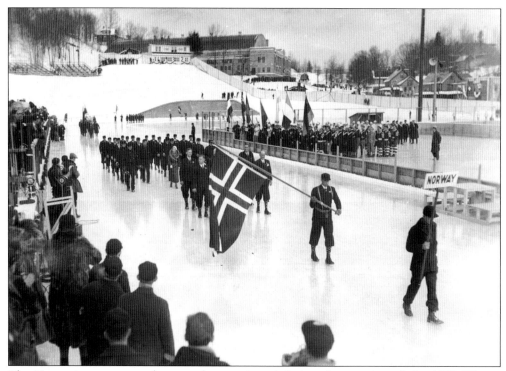

The Norwegian team parades past the grandstand during the opening of the 1932 Winter Olympics held in Lake Placid. The ceremonies were held on the speed-skating oval track in front of the high school.

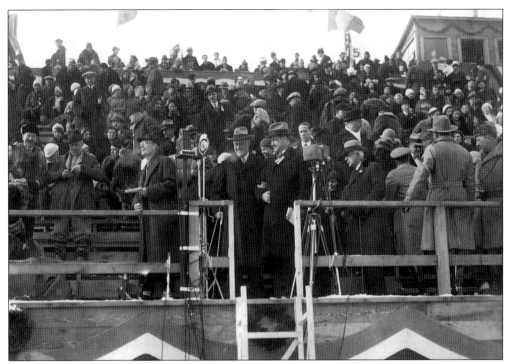

Gov. Franklin Delano Roosevelt and his wife, Eleanor, attended the opening ceremonies of the 1932 Winter Olympics. The governor would soon be elected president of the United States. Eleanor Roosevelt took a ride in a bobsled at Mount Van Hoevenburg on the opening day of the games.

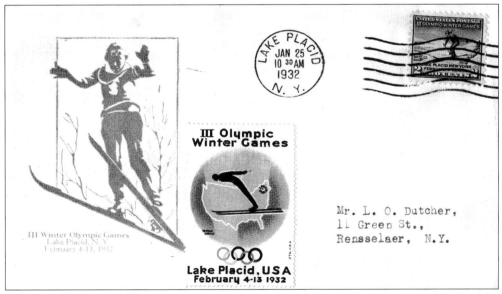

The U.S. Postal Service issued a commemorative stamp on January 25, 1932, in honor of the Lake Placid Winter Olympic games. Thousands of commercially printed first-day covers were sent to the Lake Placid post office for canceling on that first day.

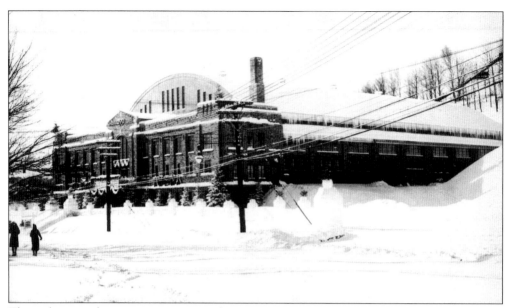

The indoor ice-skating arena is pictured c. 1935. It was completed just in time for the 1932 Winter Olympics and is still located on Main Street near the outdoor speed-skating rink. Larger, multipurpose arenas constructed for the 1980 Winter Olympics are now connected to the building.

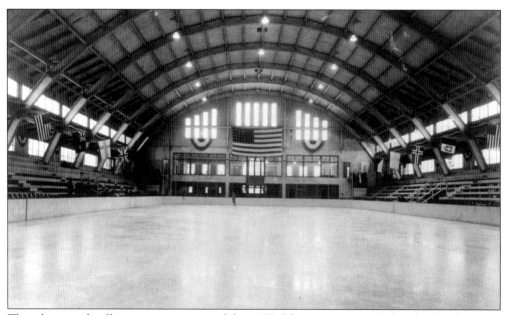

This photograph offers an interior view of the 1932 Olympic Arena at Lake Placid. The arena was dedicated on January 16, 1932, and was used for hockey and figure-skating events. Indoor ice-skating rinks would always be used in all future winter Olympic games.

Andree and Pierre Brunet of France, pictured here, won the pairs figure-skating gold medal in 1932. The American pair, Loughran and Badger, won the silver medal. The Brunets had also won an Olympic gold medal in 1928. (Photographer Roger Moore.)

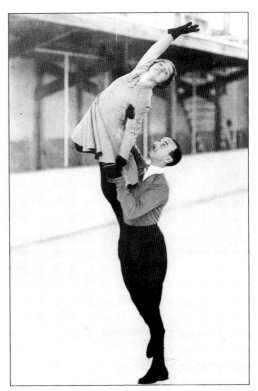

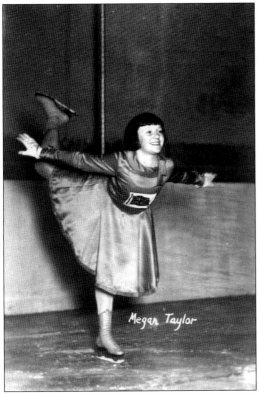

Megan Taylor was one of three 11-year-old girls from England who competed for the ladies' figure-skating medals. They were popular with the press but did not do well in competition.

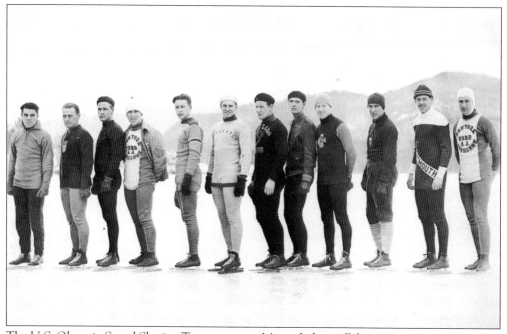

The U.S. Olympic Speed Skating Team poses on Mirror Lake on February 11, 1932. Two of the members won gold medals at the games—Jack Shea (500- and 1,500-meter races) and Irving Jaffee (5,000- and 10,000-meter races). (Photographer Roger Moore.)

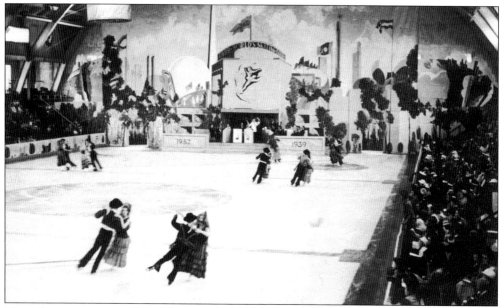

The Olympic Arena is shown during a figure-skating program at the "1939 World's Skating Fair." A live band is playing at the far end of the arena. (Photographer Odie Monahan.)

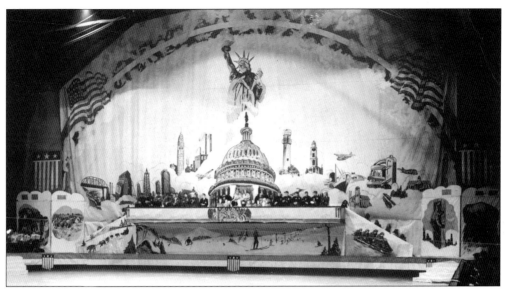

Frankie Masters and Marian Francis were crowned king and queen of winter. The ceremony was held at the Olympic Arena on December 28, 1940. (Photographer Grover Cleveland.)

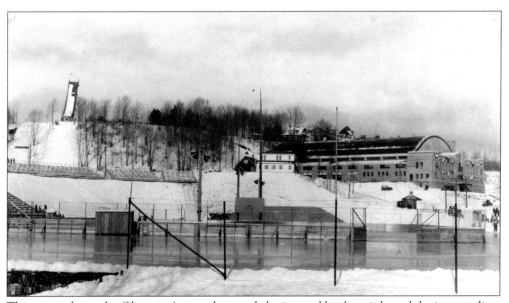

This image shows the Olympic Arena, the speed-skating and hockey rink, and the intermediate ski jump in February 1932.

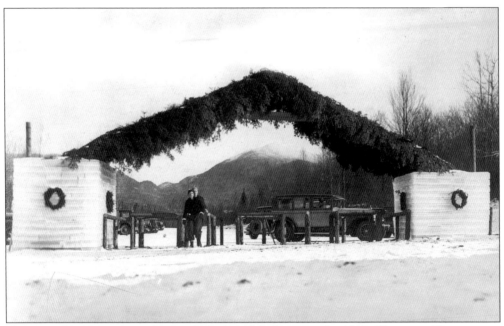

Shown is the entrance to the newly built bobsled run at the 1932 Olympics. The run was located a few miles from the village of Lake Placid at Mount Van Hoevenburg. A large ice arch welcomes spectators. (Photographer Roger Moore.)

The gold medal–winning U.S. Four Man Bobsled Team No. 1 is running high on a curve at Mount Van Hoevenberg at the 1932 Olympics. The members were Billy Fiske, Edward Eagan, Clifford Gray, and Jay O'brien.

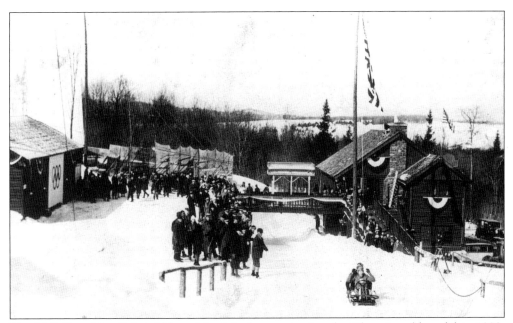

The U.S. Two Man Bobsled Team No. 1 is shown winning the Olympic gold medal in 1932. The members were Hubert and Curtis Stevens, brothers from Lake Placid.

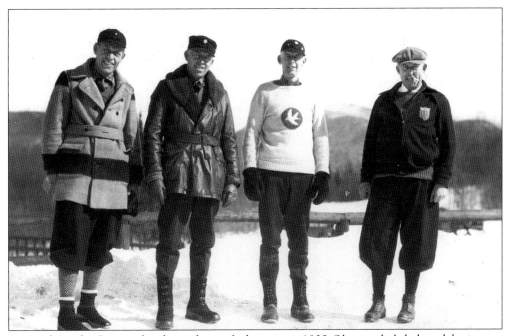

Pictured are the Stevens brothers, three of whom were 1932 Olympic bobsled medal winners. The brothers are, from left to right, Curtis, Hubert, Ray, and Paul.

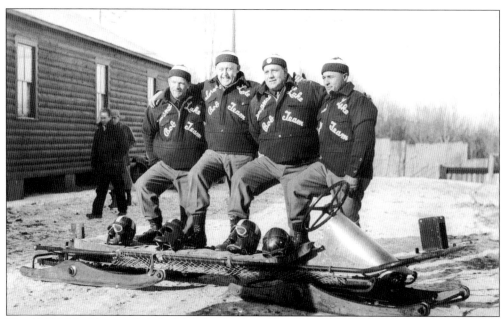

The 1932 U.S. Olympic Bobsled Team No. 2 won the silver medal at Mount Van Hoevenberg. They called themselves the Red Devils of Saranac Lake. From left to right are Ed Horton, Paul Stevens, Percy Bryant, and Henry Homberger. (Photographer Roger Moore.)

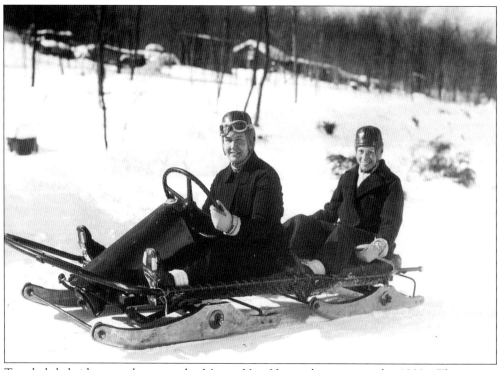

Two bobsled riders are shown at the Mount Van Hoevenburg run in the 1930s. There were teams for men and women. (Photographer Grover Cleveland.)

Sven Utterstrom of Sweden was winner of the 18-kilometer Olympic cross-country ski race in 1932. (Photographer Roger Moore.)

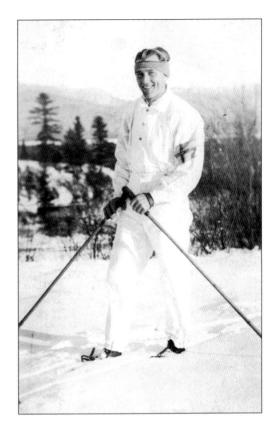

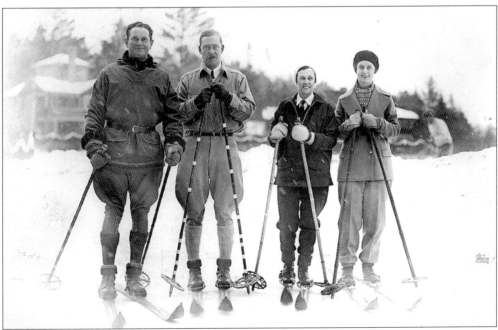

Four cross-country skiers pose at the Lake Placid Club c. 1925. Starting in 1905, club members were early pioneers in popularizing winter sports in the United States.

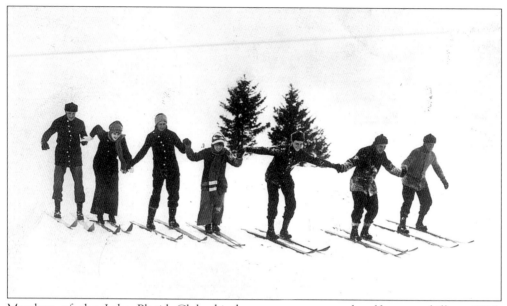

Members of the Lake Placid Club ski down a snow-covered golf course hill c. 1915. (Photographer Irving L. Stedman.)

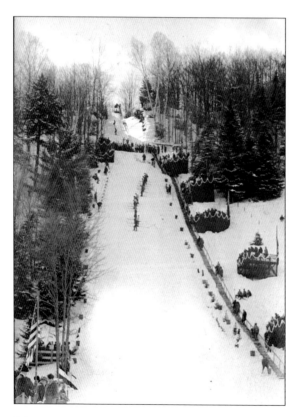

The Lake Placid Club built the first ski jump at Intervales in 1921. More spectator grandstands were added for the 1932 Olympics. The photograph was taken c. 1928.

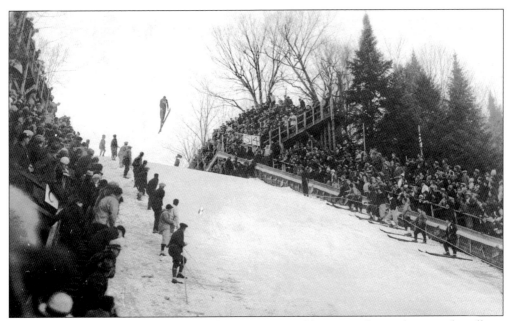

An airborne ski jumper is shown during the 1932 Winter Olympics at Intervales, near the village. The ski jumps were very popular events, drawing large crowds. (Photographer Roger Moore.)

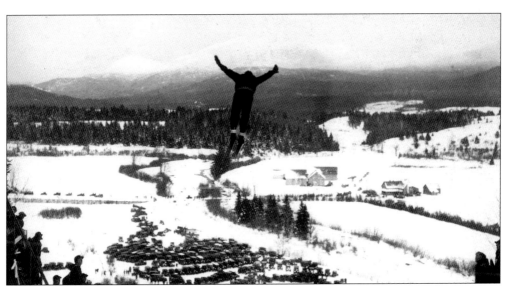

This ski jumper at the Intervales ski jump is shown c. February 1932. Note the large number of automobiles in the parking lot.

The Lake Placid Club constructed a toboggan chute using the roof of its golf clubhouse as the starting point. The card is postmarked January 28, 1912.

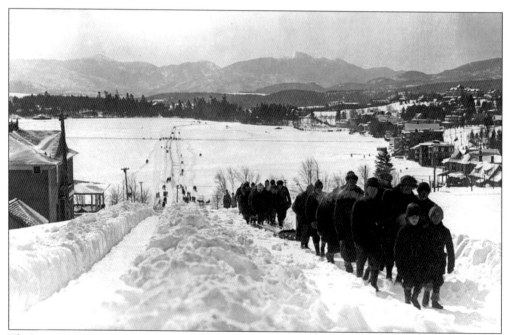

This *c.* 1920 photograph shows people climbing up Signal Hill to the starting area of a long toboggan slide. The chute travels down the hill onto Mirror Lake. Main Street buildings are in the distance. (Photographer Irving L. Stedman.)

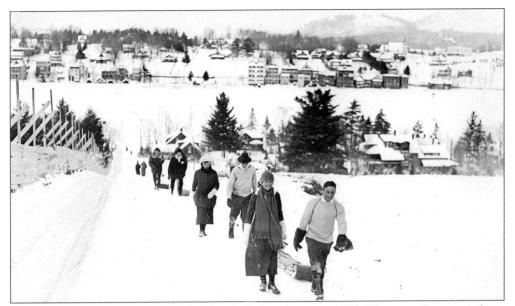

Another toboggan slide at the Lake Placid Club is shown *c.* 1920. This one also emptied out onto Mirror Lake. (Photographer Irving L. Stedman.)

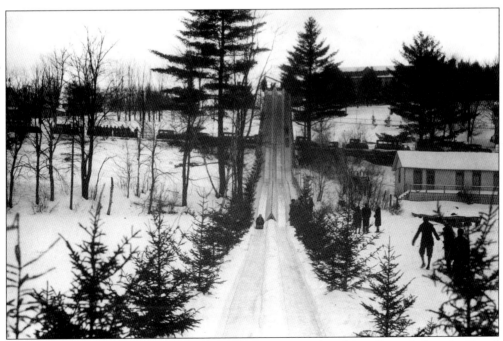

Pictured *c.* 1935, this double toboggan slide was constructed on Main Street below the Grand View Hotel. As with the others, it emptied onto Mirror Lake. (Photographer Eugene H. Pierson.)

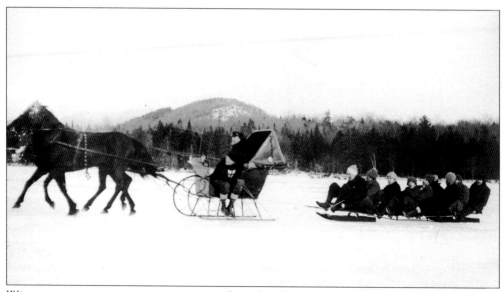

Winter activities were very important at the Lake Placid Club. A Flexible Flyer sled is being pulled by a team of horses and sleigh on Mirror Lake *c.* 1918. The thrill seekers are being towed to the toboggan run on Signal Hill. (Photographer Irving L. Stedman.)

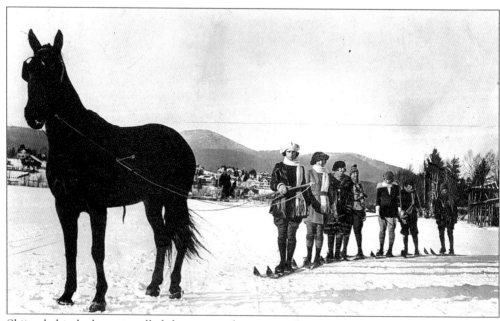

Skiing behind a horse is called skijoring and was a popular pastime on Mirror Lake at the Lake Placid Club. It was usually done with one or two people. Here, however, seven people are getting ready for a thrilling ride in 1922. (Photographer Irving L. Stedman.)

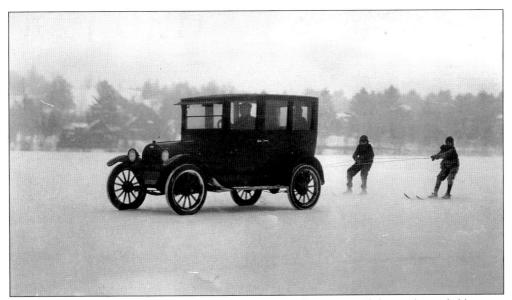

If you were really daring, you could go skijoring behind an automobile, as these children are doing *c.* 1928. (Photographer G.T. Rabineau.)

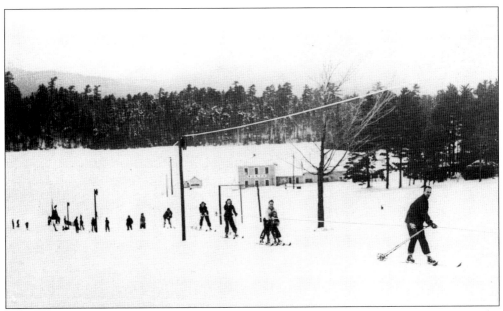

The Stevens House had a small downhill ski run on Signal Hill. In this *c.* 1935 image, the Stevens House boathouse sits in the distance on the shore of Paradox Bay. (Photographer Grover Cleveland.)

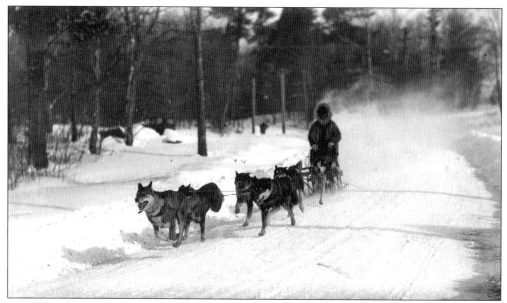

Dogsled races were held at Lake Placid, as shown in this *c.* 1935 photograph.

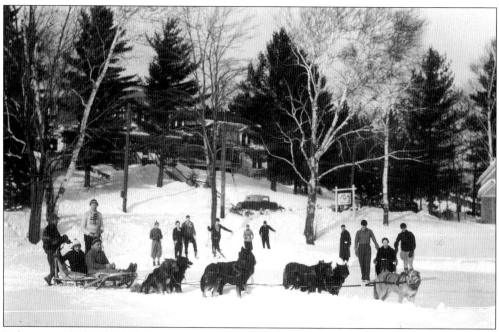

Taking people for dogsled rides was a way of earning a living for some hardy North Country entrepreneurs and still is today. This team of dogs is on Mirror Lake in front of the Mirror Lake Inn *c.* 1938. (Photographer Eugene H. Pierson.)

This *c.* 1935 photograph shows a house that was located at Jaques Suzanne's camp on Bear Cub Road. Suzanne was a world-famous dogsledder. The house was possibly the 1870s retirement home of William Appo, an accomplished black musician and composer. Movies were sometimes filmed at the compound, and Suzanne probably covered the house with bark slabs to use as a movie set. (Photographer G.T. Rabineau.)

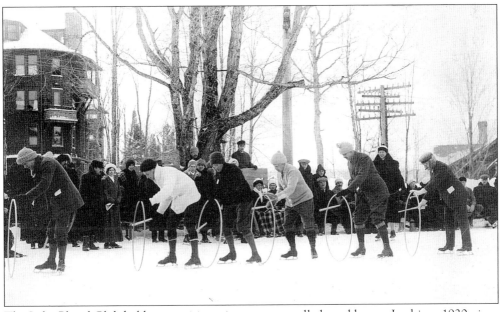

The Lake Placid Club held competitive winter events called gymkhanas. In this *c.* 1920 view, men are competing in a hoop-rolling race on ice skates. (Photographer Irving L. Stedman.)

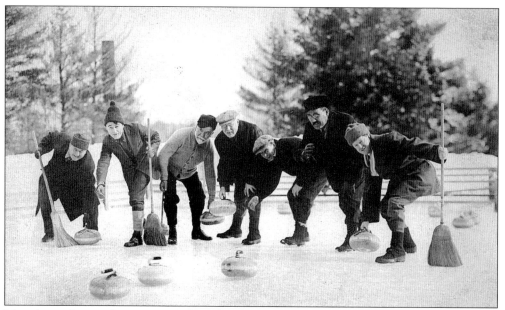

Men throw their curling stones at the Lake Placid Club *c.* 1920.

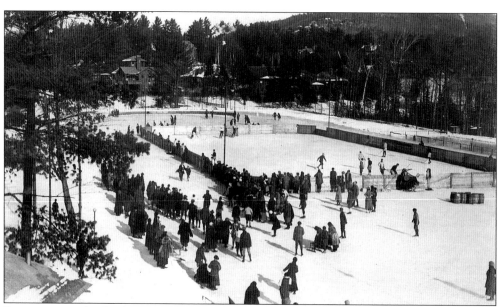

Spectators watch a hockey game at one of the Lake Placid Club's ice-skating rinks *c.* 1920.

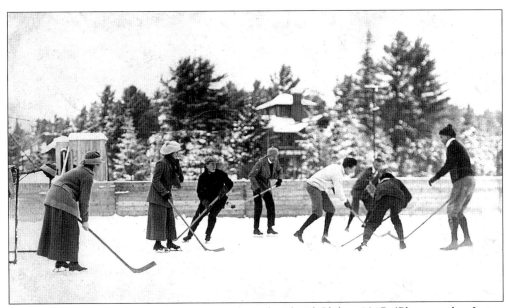

Men and women play in a hockey game at the Lake Placid Club *c.* 1917. (Photographer Irving L. Stedman.)

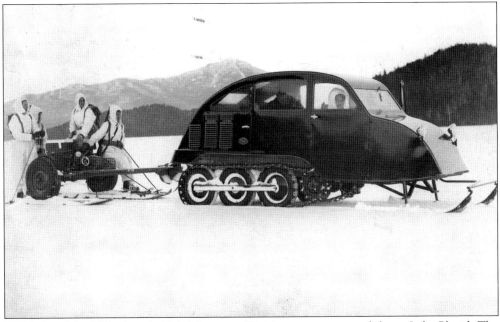

Members of the U.S. Army's 10th Mountain Division test a snowmobile on Lake Placid. The men with the trailer are using cross-country skis. The card is postmarked in January 1941.

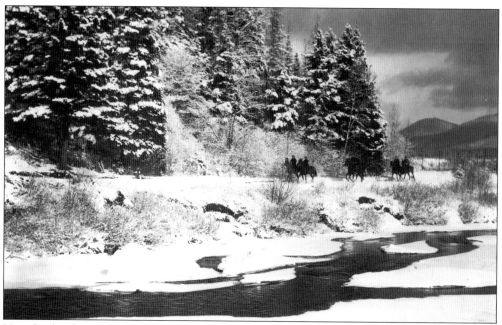

Horseback riders enjoy a winter trail ride near Lake Placid *c*. 1937.

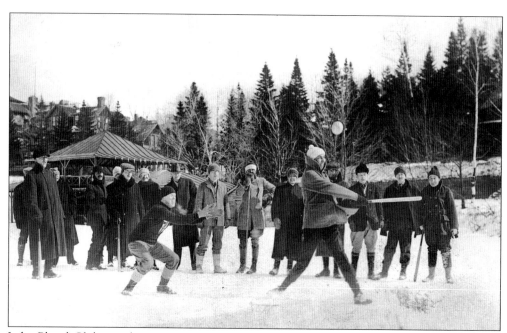

Lake Placid Club members sometimes played winter baseball on frozen Mirror Lake, as this 1918 photograph shows. (Photographer Irving L. Stedman.)

Four

THE LAKE PLACID CLUB

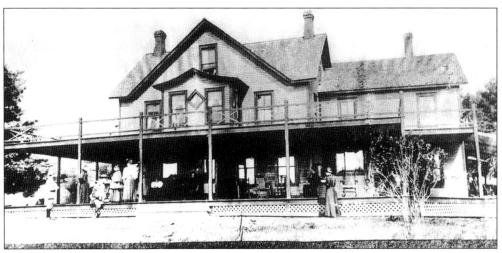

In 1895, Melvil Dewey bought a small hotel on the east shore of Mirror Lake called Bonnie Blink. This became the first building at the Placid Club, which was just being formed. The club name was soon changed to the Lake Placid Club, and the building was renamed Lakeside.

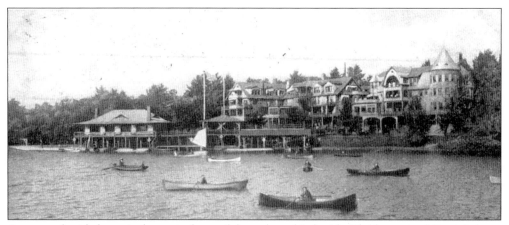

A group of guide boats is shown in front of the enlarged Lakeside Clubhouse on Mirror Lake at the Lake Placid Club. This card, postmarked in 1906, was published by Lake Placid's earliest postcard publisher, Chester D. Moses.

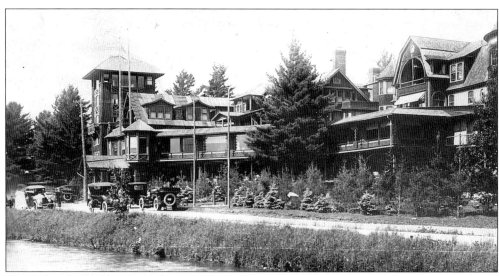

The Lakeside Clubhouse is shown with a tower addition c. 1922. People now arrived and departed Lake Placid via automobiles more than ever.

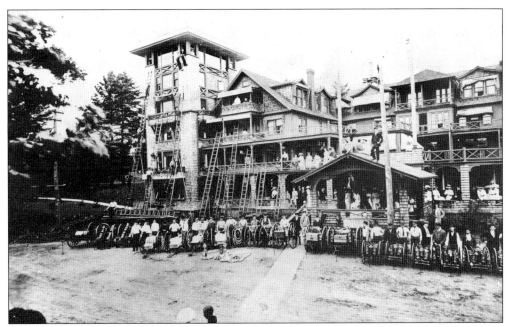

The Lake Placid Club's portable firefighting equipment is shown in this *c.* 1920 photograph. Fire drills were a required weekly activity. They held various drills to test the fire department's efficiency and speed. Fifty-foot wooden ladders were used to reach the top story of the tower.

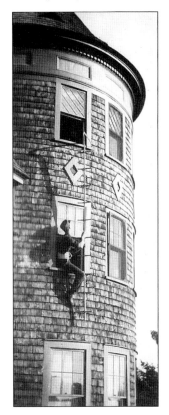

A Lake Placid Club fireman hooks a scaling ladder to a window sill before climbing higher on the Lakeside tower *c.* 1915. (Photographer Irving L. Stedman.)

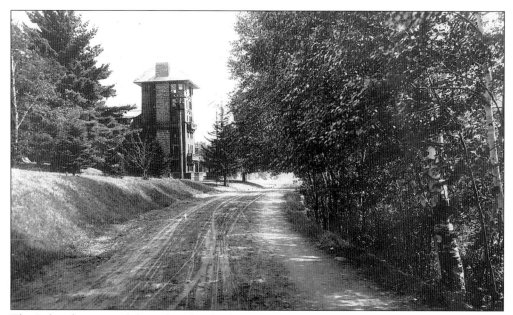

The Lakeside tower of the Lake Placid Club is shown *c.* 1915. Shore Drive is now known as Mirror Lake Drive. (Detroit Publishing Company, Detroit, Michigan.)

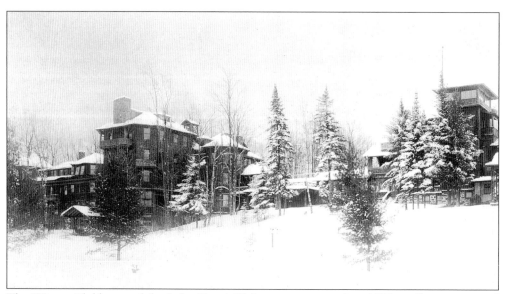

The Winter Clubhouse of the Lake Placid Club was constructed in 1907 to allow year-round use of club facilities. By then, the club was actively promoting winter sports for its members.

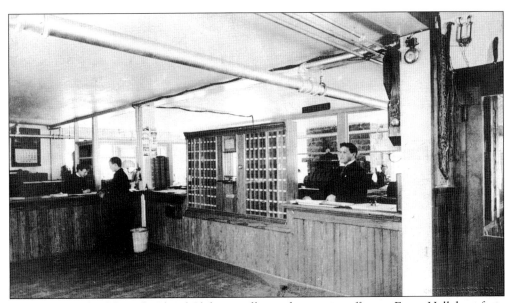

This photograph of the Lake Placid Club post office and executive offices at Forest Hall dates from c. 1910. In the middle are post-office boxes for the guests' mail. Young clerks stand ready to help the guests. The photograph was taken by Chester D. Moses, the first official club photographer.

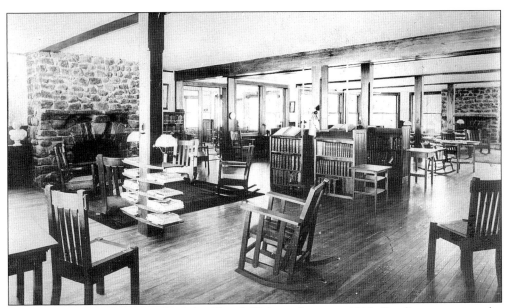

The Forest Hall Library, at the Lake Placid Club, is shown c. 1910. Reading was a popular pastime with club members.

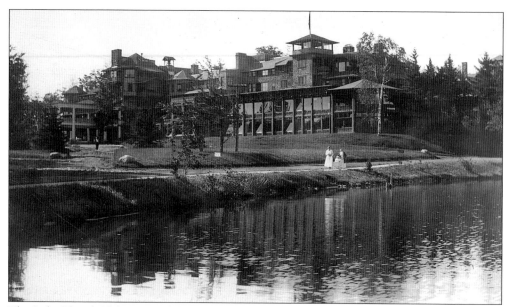

The Lake Placid Club Forest clubhouse is pictured *c.* 1915. The Mirror Lake shore provides a great place for a summer stroll. The unoccupied clubhouse burned to the ground due to arson in October 1992.

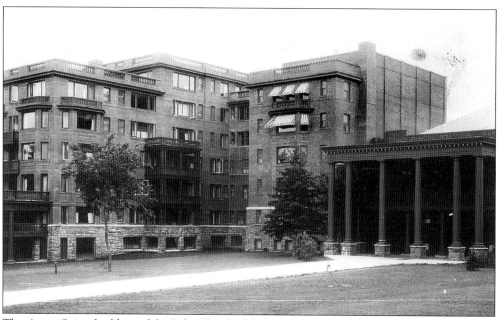

The Agora Suites building of the Lake Placid Club was constructed in 1924. The entrance to the Agora Theater is on the right. This building survived the arson fires of the 1990s but was torn down in January 2002. No major club buildings remain standing. ($5.00 Photo Company, Canton.)

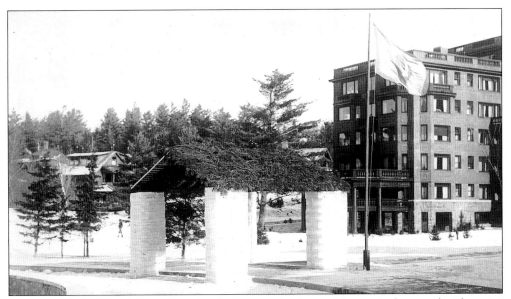

One of the Lake Placid Club driveways in front of the Agora Theater is decorated with an ice arch *c*. 1935. A Sno-Birds flag flies from the flagpole. The Sno-Birds promoted winter sports activities at the club. (Photographer Grover Cleveland.)

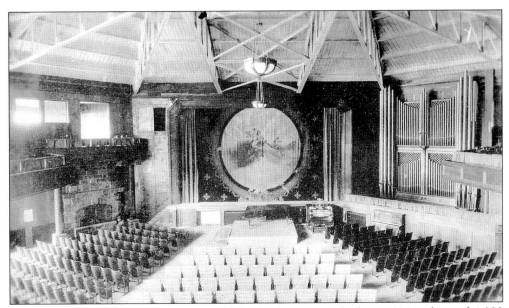

The club's Agora Theater is shown *c*. 1930. The theater was built in 1924 and seated 1,200 people. It was demolished in January 2002.

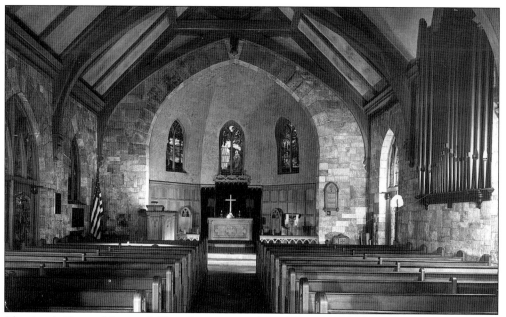

The Annie Dewey Memorial Chapel, constructed in 1924, originally had beautiful stained-glass windows custom built by Tiffany Studios. The windows were removed some years ago and have been saved from destruction, but they are no longer in Lake Placid. The card is postmarked 1958.

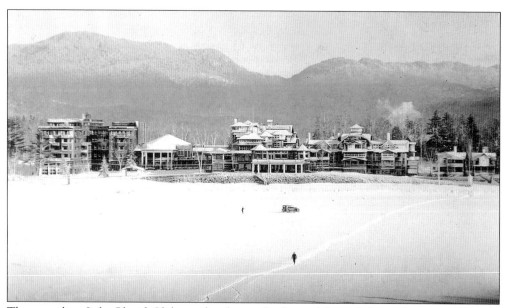

The sprawling Lake Placid Club on the shore of a frozen Mirror Lake is shown c. 1935. As someone walks on the ice to Main Street, a lone person is skijoring behind an automobile.

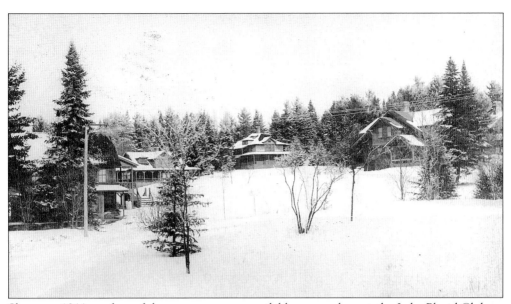

Shown *c.* 1911 are four of the many cottages available to members at the Lake Placid Club.

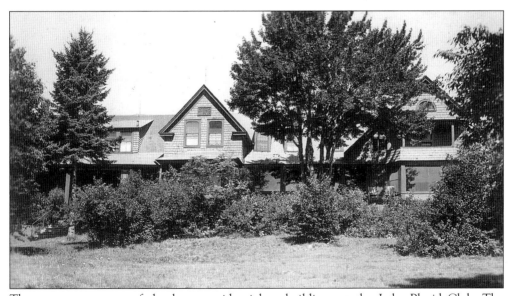

Theonoguen was one of the larger residential outbuildings at the Lake Placid Club. The building was destroyed by an arson fire in 1991.

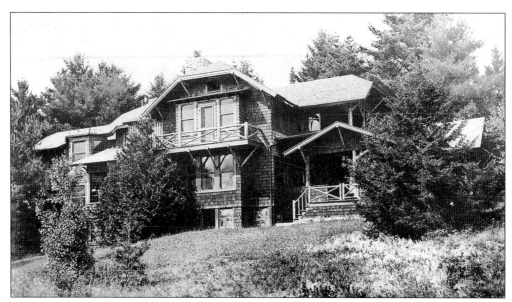

Cedars Cottage at the Lake Placid Club is pictured c. 1912. This cottage was Melvil Dewey's son Godfrey's residence at one time.

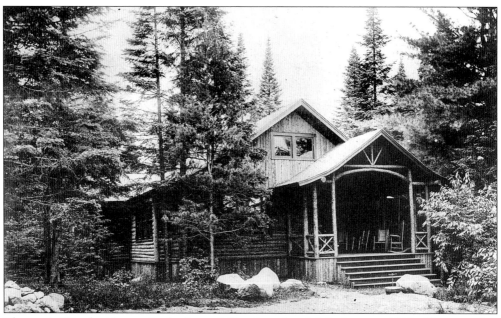

The rustic Wanika Cottage in the Iroquoi Woods at the club is shown c. 1912. (Photographer Irving L. Stedman.)

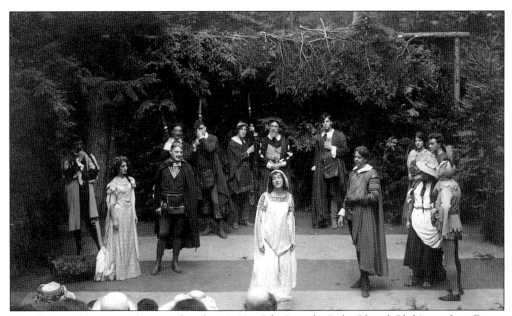

The Coburn Players perform in the play *As You Like It* at the Lake Placid Club's outdoor Forest Theater *c.* 1915. The club had no indoor theater until 1924.

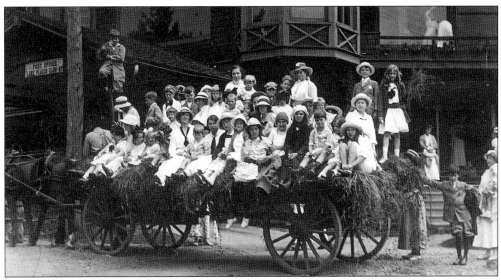

Children enjoy a hayride at the Lake Placid Club *c.* 1915. There were many activities for even the young members of the club. (Photographer Irving L. Stedman.)

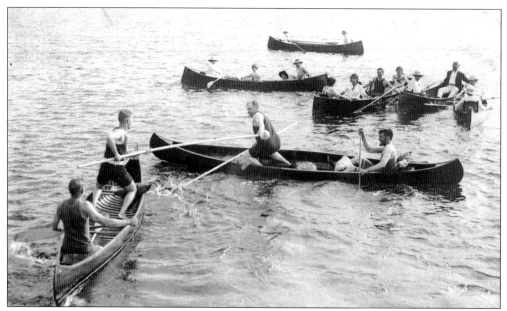

This Lake Placid Club photograph shows two teams in a canoe-tilting match on Mirror Lake c. 1920. Competition events among members were a common occurrence at the club. Spectators in their canoes watch the battle intently.

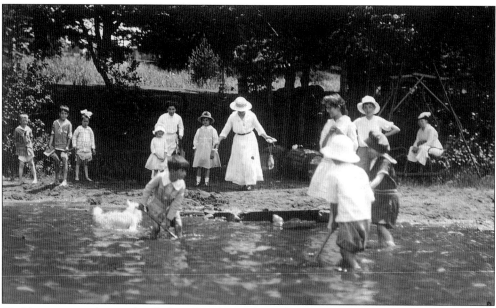

Children are at play at the "babies beach" at the Lake Placid Club c. 1915. (Photographer Irving L. Stedman.)

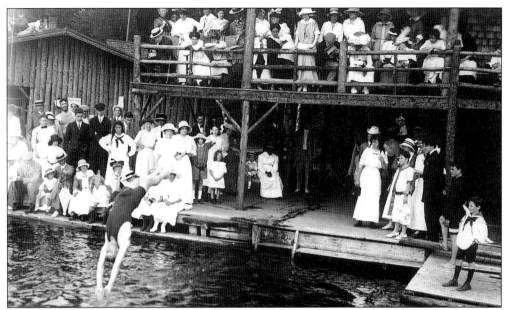

In this *c.* 1915 view of a diving exhibition at the Lake Placid Club, spectators line the porch railing at the Lakeside Boathouse. (Photographer Irving L. Stedman.)

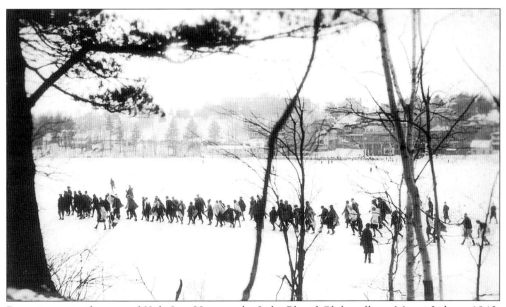

Participants in the annual Yule Log Hunt at the Lake Placid Club walk on Mirror Lake *c.* 1940. After the hidden log was found, it was dragged to a bonfire area and lit during the evening celebration.

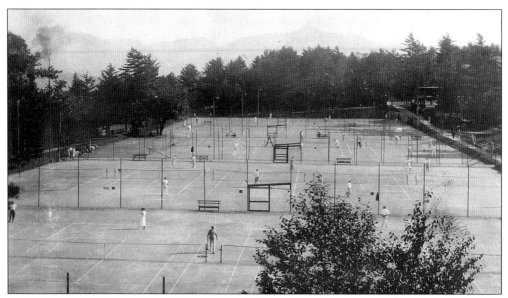

A few of the 22 tennis courts at the Lake Placid Club are shown c. 1925. Some of the courts were flooded with water in the winter to make ice-skating rinks.

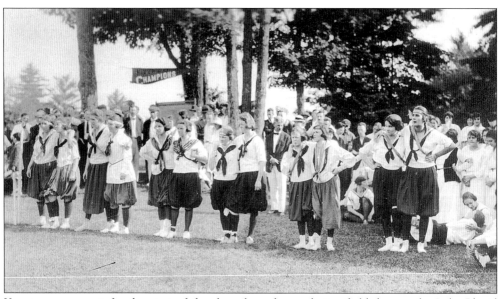

Young women wait for the start of the three-legged race during field days at the Lake Placid Club c. 1925. The field days were held for club employees to compete against each other in various organized games.

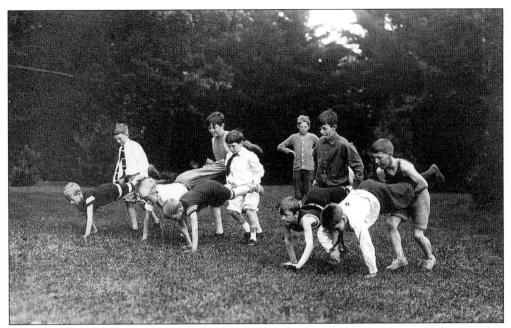

Young boys compete in a wheelbarrow race at the Lake Placid Club c. 1920. (Photographer Irving L. Stedman.)

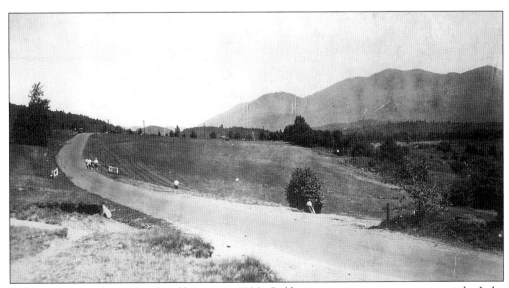

This view shows the Mohawk golf course c. 1920. Golf was a very important activity at the Lake Placid Club. Seymour Dunn was the club pro for many years.

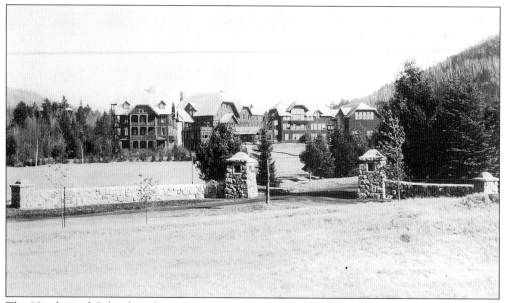

The Northwood School at the Lake Placid Club is shown c. 1940. The private school is still operating and looks virtually the same today.

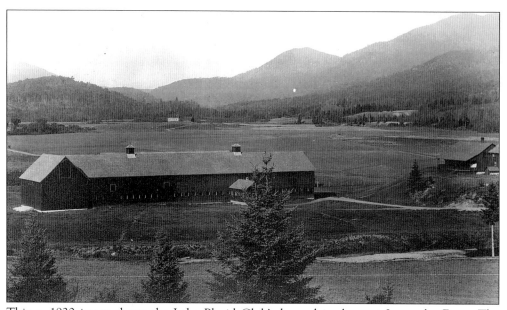

This c. 1920 image shows the Lake Placid Club's large dairy barn at Intervales Farm. The Sentinel Mountains are in the distance.

Five

MISCELLANEOUS

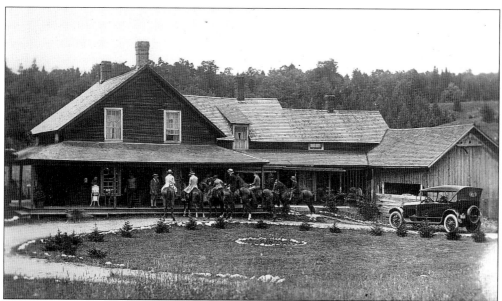

Abolitionist John Brown's farmhouse is pictured *c.* 1925. The farm is located a couple of miles from the village, in the town of North Elba. (Photographer Irving L. Stedman.)

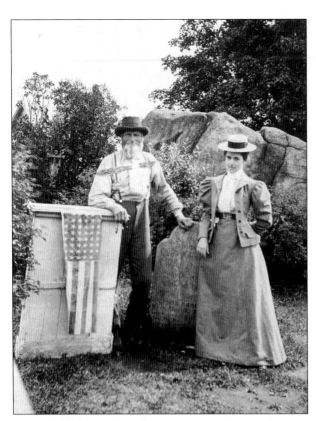

A young woman visits the grave of John Brown in August 1898. The man (probably a caretaker) has removed the wooden cover that protected the grave from relic fiends. Later, a permanent cover was built with clear-glass panels.

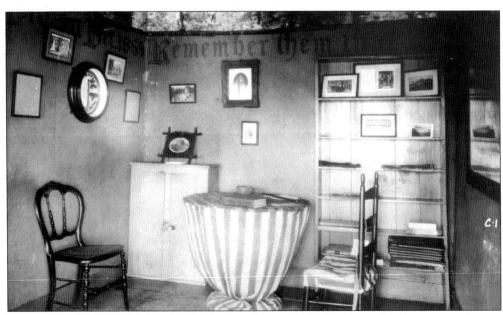

This interior view of John Brown's house dates from c. 1950. The house has been a popular site to visit since before 1900. ($5.00 Photo Company, Canton.)

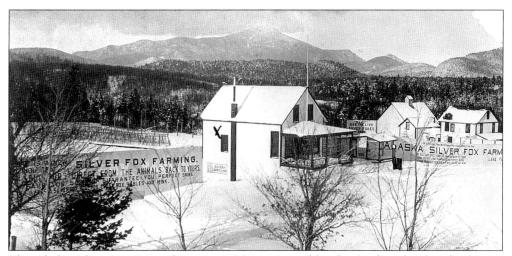

The Alaska Silver Fox Farm, shown *c.* 1925, was owned by the Sterling family. The famous tourist attraction grew in size and was later known as 1,000 Animals. The main building still exists and is now a garden center.

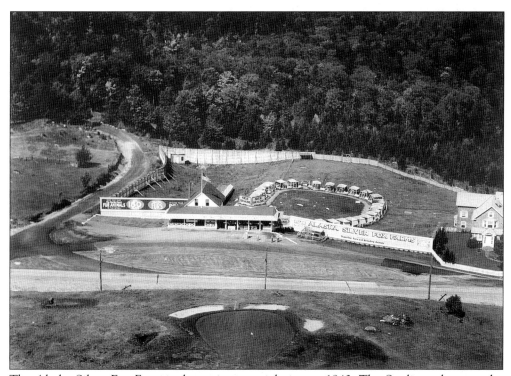

The Alaska Silver Fox Farm is shown in an aerial view *c.* 1940. The Sterlings also owned a similar attraction at Ausable Chasm. Whiteface Inn Road is on the left, going into the woods. (Photographer Roger Moore.)

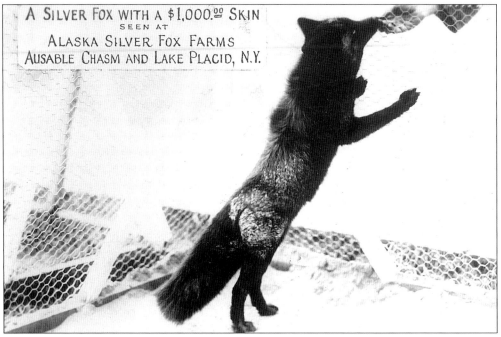

Pictured in 1928 is one of Sterlings' silver foxes, valued then at $1,000.

The Heaven Hill Farm, shown *c.* 1950, was owned by Henry Uihlein. Uihlein raised prize-winning show cattle, grew seed potatoes, and produced maple syrup. He purchased the farm in the early 1940s.

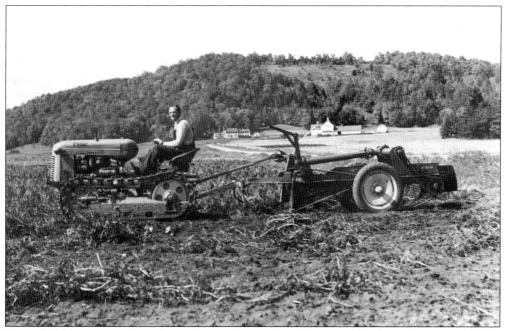

Henry Uihlein was a well-to-do gentleman farmer who did some of the farm chores himself. He is shown harvesting potatoes with a Cletrac tractor *c*. 1950.

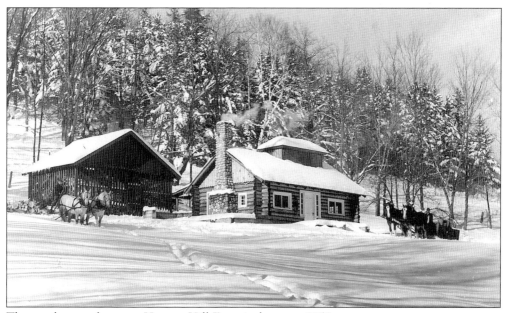

The maple sugar house at Heaven Hill Farm is shown *c*. 1950.

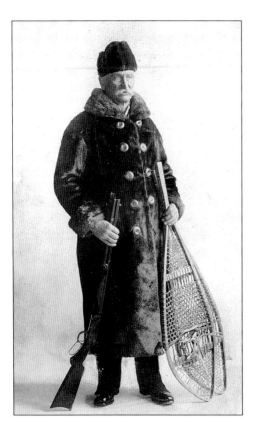

Sanford "Speen" McKenzie was a local hunter and guide who came to Lake Placid in the early 1890s. He had a watch and jewelry shop in the village. This formal portrait was taken c. 1908.

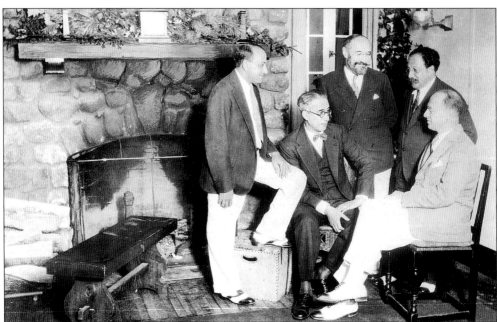

In 1925, Clarence Adler opened his music camp Ka-ren-ni-o-ke on Averyville Road near the village. Famous musicians Aaron Copland and Ernest Bloch stayed at the camp over the years. The photograph was taken c. 1935.

This photograph offers a beautiful view of Whiteface Mountain *c*. 1930. The rustic open camp was located near Lake Placid village. (Photographer G.T. Rabineau.)

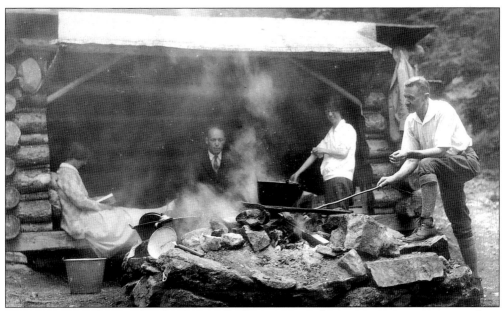

Campers enjoy a fire at Lake Placid *c*. 1945. The rustic open lean-to gives some protection from bad weather.

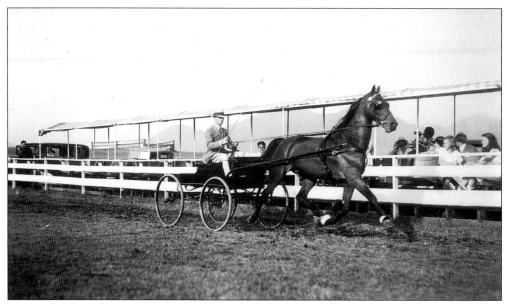

This *c.* 1935 view shows a horse and buggy at the horse show grounds in North Elba. The annual horse show is still a very popular attraction today.

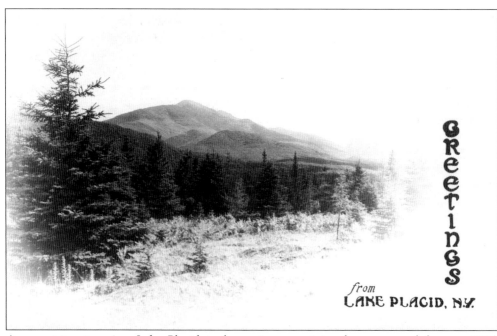

Greetings from LAKE PLACID, N.Y.

A mountain view near Lake Placid is shown in an artistic photo postcard from *c.* 1935. (Photographer Roger Moore.)